PAINTERS IN PARIS
1895–1950

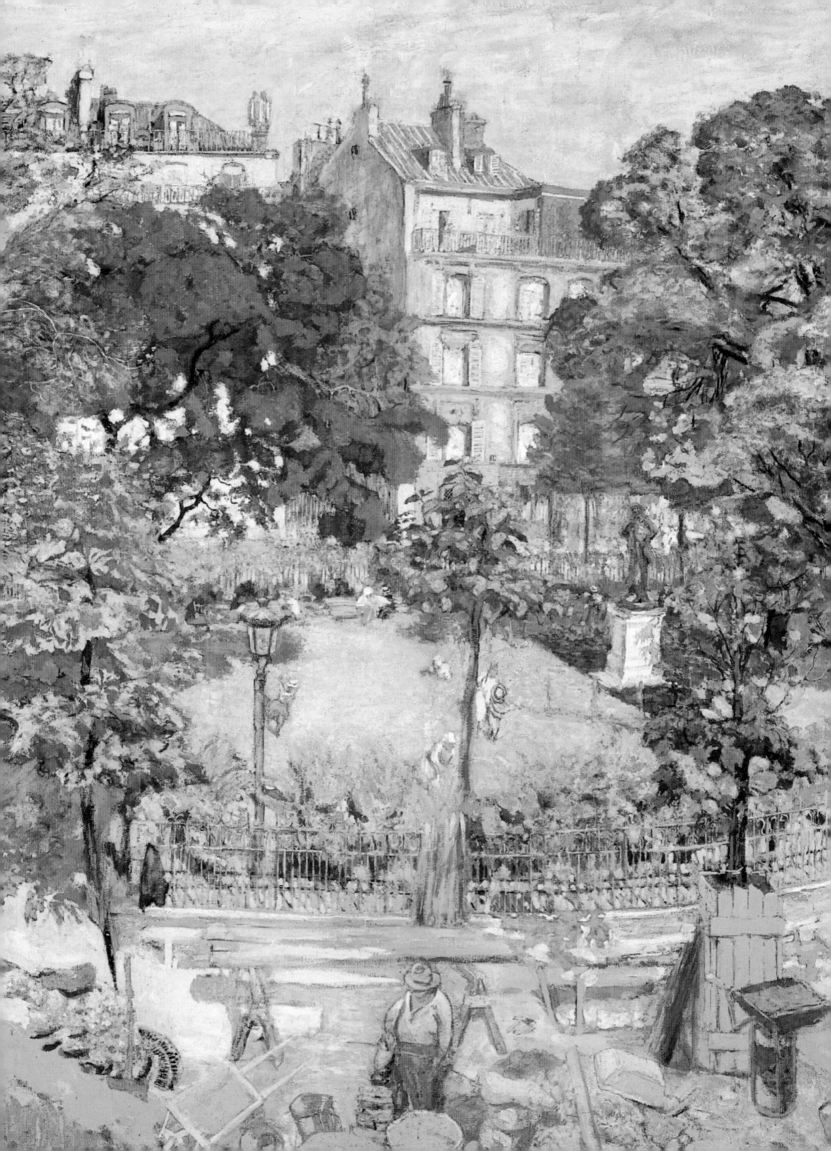

PAINTERS IN PARIS
1895-1950

William S. Lieberman

THE METROPOLITAN MUSEUM OF ART

In association with Yale University Press, New Haven and London

This catalogue is published in conjunction with the exhibition "Painters in Paris: 1895–1950" held at The Metropolitan Museum of Art, New York, March 8–December 31, 2000.

The exhibition is sponsored by **Ætna**.

This publication is made possible by the Blanche and A. L. Levine Fund.

Published by The Metropolitan Museum of Art, New York

John P. O'Neill, Editor in Chief

Joan Holt, Project Manager

Bruce Campbell, Designer

Peter Antony, Production Manager, with the assistance of Sally VanDevanter and Elisa Frohlich

Robert Weisberg, Desktop Publishing

Separations by Professional Graphics Inc., Rockford, Ill.; printing by Meridian Printing, East Greenwich, R.I.

All photography, unless otherwise noted, by The Metropolitan Museum of Art Photograph Studio: Page 25 © 2000 by Corbis/Bettman; page 98, by Michael Tropea.

Front cover: *Reclining Nude*, by Amedeo Modigliani (see page 86). Frontispiece: Detail of *Place Vintimille, Paris*, by Edouard Vuillard (see pp. 84–85)

Third printing 2000

Library of Congress Cataloging-in-Publication Data

Lieberman, William Slattery, 1924–
 Painters in Paris: 1895–1950 / William S. Lieberman.
 p. cm.
 Exhibition dates, March 8–December 31, 2000 at the Metropolitan Museum of Art.
 ISBN 0-87099-947-8 (alk. paper)—ISBN 0-300-08679-2 (Yale : alk. paper)
 1. École de Paris—Exhibitions. 2. Painting, Modern—20th century—France—Paris—Exhibitions. 3. Painting—New York (State)—New York—Exhibitions. 4. Metropolitan Museum of Art (New York, N.Y.)—Exhibitions. I. Title.

ND550.L54 2000
759.4′361′0747471—dc21
 99-088310

Contents

Director's Note

This illustrated selection of paintings in the Metropolitan Museum, many done in Paris between 1895 and 1950, represents but a small—albeit not the least—part of our holdings in this area. Because of the paucity of space in the Lila Acheson Wallace Wing and the frequent rotation of the art on view, the public cannot easily grasp the high level of quality and broad scope of this collection.

The publication and exhibition are meant to provide a more complete view of our works of the School of Paris. We are also fortunate to be able to include nine paintings from the Jacques and Natasha Gelman Collection, recently bequeathed to the Metropolitan.

In the presentation of these works, many of which have been previously published, we have opted for an approach that challenges and provokes both visual and historical curiosity: the organization of the catalogue—the apposition of images—was Bill Lieberman's own personal way of achieving this. As the second part of the publication makes clear, the years of his chairmanship of the Department of Twentieth Century Art, now the Department of Modern Art, have been particularly fruitful for the enrichment of the collection. All of us, and the public first and foremost, can be grateful to him for his remarkable record of acquisitions.

The Museum extends its warmest thanks to Aetna for its generous support of the exhibition. We are also indebted to the Blanche and A. L. Levine Fund for making this accompanying publication possible.

Philippe de Montebello
Director

Sponsor's Statement

As we celebrate the dawn of a new century, Aetna is proud to sponsor the Metropolitan Museum's exhibition of its extraordinary holdings of an essential aspect of twentieth-century art, entitled "Painters in Paris: 1895–1950."

The thirty-eight modern painters of diverse nationalities represented in the exhibition made the City of Light the center of the art world for more than fifty years and shaped the art of an entire century. The exhibition recalls a period and place of great vitality, when artists began to see their world in profoundly different ways. Matisse, Picasso, Braque, Modigliani, Chagall, de Chirico, and others shattered the boundaries of the status quo to create the new genres of Impressionism, Fauvism, Cubism, and Surrealism.

Just after the turn of the century when the modern art movement took hold in Europe, Aetna had been in business for fifty years. Since 1853, Aetna has been a leader in helping individuals and families protect against life's risks. Today Aetna provides nearly forty million people worldwide with innovative products and services that help them manage best what matters most to them: their health and financial well-being.

As we embark on a new century, Aetna is delighted to join in paying homage to these groundbreaking artists and in celebrating the triumph of imagination and vision their work represents.

Richard L. Huber
Chairman
Aetna

PAINTERS IN PARIS
1895-1950

Introduction

The following pages offer a visual chronicle that illustrates one aspect of the Metropolitan Museum's involvement with the arts of the last hundred years.

During the first decades of the twentieth century certain painters and sculptors working in France found new and innovative ways of expression. Many of these artists, of course, were French. Half, however, were foreigners who had recently arrived in Paris from other countries.

The paintings reproduced in this survey were created between 1895 and 1950. All are from the collection of the Metropolitan Museum. The earliest to be acquired is Picasso's portrait of Gertrude Stein, the American writer who lived in France. In 1947, when her bequest was accessioned, it presented the Museum with its first painting by Picasso. The picture was also the Metropolitan's first by a living artist of the School of Paris. Miss Stein's gift had not been anticipated, but it did provide an unexpected cornerstone upon which a "modern" collection might be built. The Museum had already assembled a significant representation of American painting of the first half of the twentieth century.

In 1987, forty years after Miss Stein's bequest, the Museum inaugurated the Lila Acheson Wallace Wing, devoted to its holdings of twentieth-century art. This publication illustrates how the collection grew, particularly in the past two decades.

The history of modern painting traditionally begins in the 1870s in France with the Impressionists: Pissarro, Manet, Degas, Sisley, Monet, and Renoir. They lived in Paris, and they exhibited as a group. Redon, a Symbolist painter, was born in 1840, a decade after Pissarro. Cézanne, who built upon Impressionism, was born in 1839. He and the younger artists Gauguin, Seurat, and van Gogh are the four significant Postimpressionist masters.

Longevity occasionally blurs generations, and it does not always convenience orderly progressions preferred by art historians. Van Gogh and Seurat died in 1890 and 1891, Gauguin and Cézanne in 1903 and 1906. Some Impressionist painters, however, lived longer than their stylistic successors. Degas, for instance, died in 1917 and Renoir two years later. Monet lived until 1926, and his late series of nymphaeas as well as his earlier views of London belong to the twentieth century. Modigliani, a quintessential painter of the twentieth-century School of Paris, died six years before Monet. National identities also became blurred. For instance, Pascin, born in Bulgaria, matured in Austria and Germany, and traveled in Cuba before becoming a citizen of the United States in 1920. For most of his brief life, however, he lived and worked in France.

In 1907 and 1913 the first paintings by Renoir and Cézanne acquired by an American museum were purchased by the Metropolitan. Little further attention was paid to European painting of the recent past until 1929, when the Metropolitan received the bequest of Louisine Havemeyer. Her munificent legacy includes an additional painting by Renoir, five by Cézanne, two still lifes and six landscapes by Monet painted before 1900, and an astonishing 113 paintings, drawings, bronzes, and prints by Degas. In 1949 and 1951 paintings by Gauguin, van Gogh, and Seurat also entered the collection. Today, after a half century, the Museum's representation of the Impressionists and the Postimpressionists has become comprehensive, and it is displayed in the sequence of galleries devoted to nineteenth-century European painting, which includes the Walter H. and Leonore Annenberg Collection.

The Museum's twentieth-century paintings are shown in the Lila Acheson Wallace Wing. In this survey, however, one by Vuillard and one by Derain belong to the Robert Lehman Collection, which is housed in a separate wing. The Lehman Collection also includes additional paintings by Balthus, Bonnard, Braque, Chagall, Marquet, Matisse, Rouault, Utrillo, Villon,

and Vlaminck. The Annenberg Collection contains additional paintings by Bonnard, Braque, Matisse, Monet, Picasso, and Vuillard.

During the first half of the twentieth century, France continued to be central to artistic development. Although most of the painters and sculptors of the polyglot School of Paris knew each other, they never exhibited together as a group. Some were briefly partners; some were mentors; others followed. Paris was home to all of them, but they share no single style. Their nationalities were also diverse: Kupka was Czech; Ernst was German; de Chirico, Modigliani, and Severini were Italian; Lipchitz and Soutine were Lithuanian; Rivera was Mexican; Brancusi was Romanian; Chagall, Gabo, Gontcharova, Pevsner, and Tchelitchew were Russian; Gris, Miró, and Picasso were Spanish; Vallotton was Swiss; and Archipenko was Ukrainian.

Why did these artists choose to come to Paris?

Gertrude Stein suggested several reasons. "Foreigners," she said, "belong in France because they have always been here and did what they had to do there and remained foreigners there. Of course they all came to France, a great many to paint pictures. So it begins to be reasonable that the twentieth century needed the background of Paris, the place where tradition was so firm that they could let anyone have the emotions of unreality. Paris was where the twentieth century was."

· · · · · ·

The paintings reproduced are arranged in two sections that encourage the study of the growth of the collection: first, those accessioned between 1947 and 1978; second, more recent acquisitions accessioned between 1979 and 1999. Within both sections the sequence of paintings is loosely chronological. Facing pages invite comparisons and contrasts.

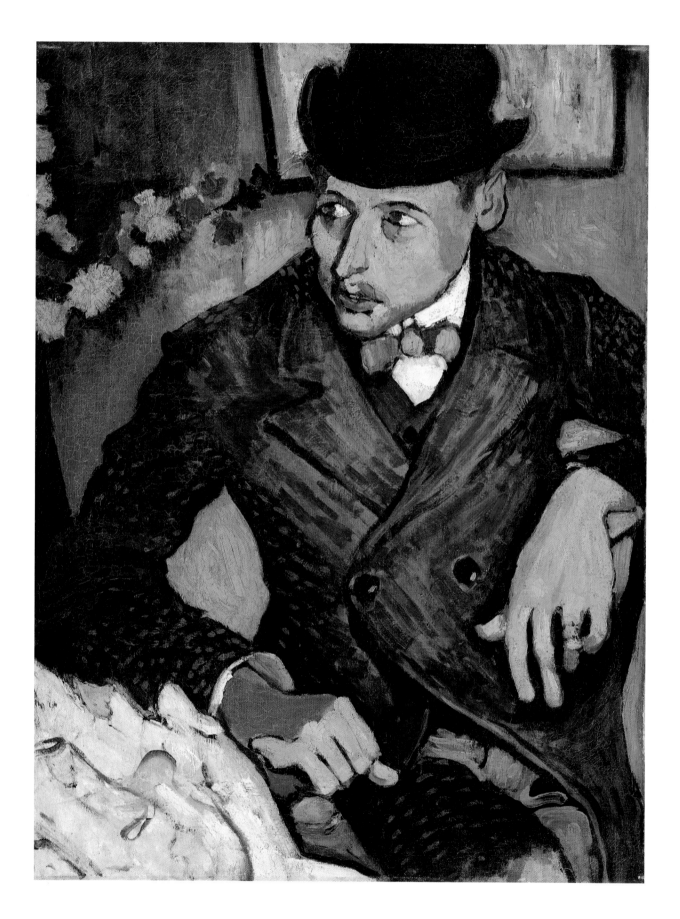

ACQUISITIONS 1947–1978

In September 1947 an agreement was signed by three museums in New York: The Metropolitan Museum of Art, founded in 1870; the Museum of Modern Art, founded in 1929; and the Whitney Museum of American Art, founded in 1930. John Hay Whitney, then chairman of the Modern's Board of Trustees, summarized the main thrust of the agreement: "the Museum of Modern Art will sell to the Metropolitan Museum paintings and sculptures which the two museums agree have passed from the category of modern to that of historic. In this way the Metropolitan will be assured of securing representative painting and sculpture by recent artists for its great survey of the art of the past, while the Museum of Modern Art will live up to its name by keeping its collection modern."

At the time the Metropolitan lent to the Modern the Picasso portrait recently bequeathed by Gertrude Stein and a bronze cast of Maillol's *Chained in Action*, which had been purchased in 1929. Alice B. Toklas, Stein's companion, was very much opposed to the transfer of the Picasso portrait and wrote so. Her letters from Paris addressed to officials of the Metropolitan are transcribed on pages 23–25.

The intermuseum agreement was uneasy, and it did not last. The Metropolitan, however, purchased several works from the Modern, among them drawings by Seurat and two paintings by Picasso, *The Coiffure* and *Woman in White*. In 1950 and 1952 friends of the Metropolitan made possible the acquisition of two additional early paintings by Picasso, *The Blind Man's Meal* and *The Actor*.

In 1949 the Metropolitan Museum received the major portion of the collection of Alfred Stieglitz, the American photographer who in his early years had championed in exhibition and publication not only photography but also sculpture and painting by several artists of the European avant-garde. The collection, a gift of his wife, the painter Georgia O'Keeffe, primarily consisted of American painting and drawings. However, the Stieglitz Collection also included bronzes by Brancusi and Matisse, paintings by Kandinsky, Rivera, and Severini, as well as drawings by Matisse, Picabia, and Picasso.

In 1967 a second major gift was the collection of Adelaide Milton de Groot, herself a painter, which presented the Museum with its first works by Dufy, Matisse, Modigliani, Pascin, Segonzac, Soutine, Utrillo, and Vallotton, all artists of the School of Paris. Individual twentieth-century paintings were acquired through bequests that also contained earlier works. Among these were the bequests of Sam A. Lewisohn in 1951, Julia W. Emmons in 1956, and Robert Lehman in 1975.

The threat and the fact of World War II brought to the United States several artists of the School of Paris. In 1950 and 1955, after Tchelitchew and Tanguy became citizens of the United States, it was possible for the Museum to purchase their paintings through funds established in 1906 and 1911 by George A. Hearn that are reserved for American works. One wonders what Mr. Hearn might have thought of such acquisitions.

Among the forty early acquisitions reproduced here, ten were purchases: Bonnard's *The Green Blouse*, Derain's *The Table*, Kupka's *Vertical and Diagonal Planes*, Metzinger's *Table by a Window*, Vuillard's *Morning in the Garden at Vaucresson*; two paintings by Picasso from the Museum of Modern Art; a third Picasso acquired through funds contributed by Mr. and Mrs. Ira Haupt; and the paintings by Tanguy and Tchelitchew.

.

With works on paper, the Metropolitan was more adventuresome. For instance, the Museum's first three drawings by Matisse were gifts of Mrs. Florence Blumenthal in 1910; and in 1929 thirty-five of Matisse's etchings, all portraits of his friends and family, were purchased through the Rogers Fund. Earlier in the century and in a different medium, Rodin himself had collaborated with the Museum in forming its collection of his sculpture.

André Derain.
French, 1880–1954

Lucien Gilbert 1906
Oil on canvas
32 x 23 3/4 in. (81.3 x 60.3 cm)

Gift of Joyce Blaffer von Bothmer, in memory of Mr. and Mrs. Robert Lee Blaffer, 1975
1975.169

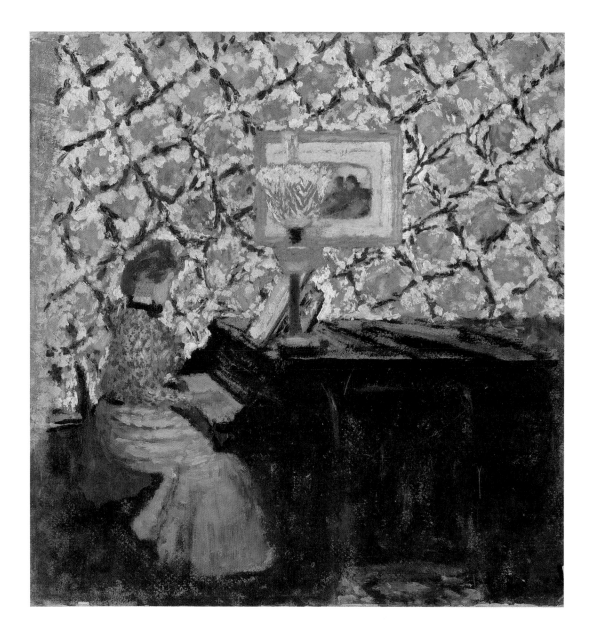

Edouard Vuillard. French, 1868–1940

Girl at a Piano ca. 1899
Oil on cardboard
18 1/2 x 17 1/2 in. (47 x 44.5 cm)

Robert Lehman Collection, 1975
1975.1.224

Pierre Bonnard. French, 1867–1947

The Family of Claude Terrasse 1899
Oil on canvas
32 1/2 x 27 in. (82.6 x 68.6 cm)

Gift of Harry N. Abrams, 1965
65.250

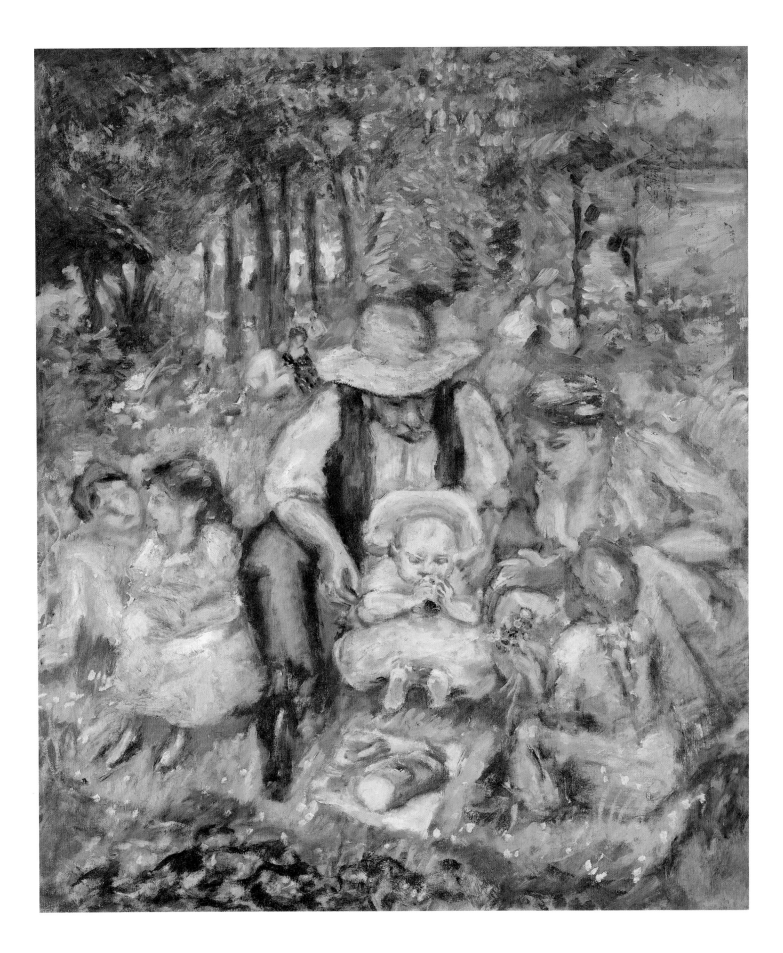

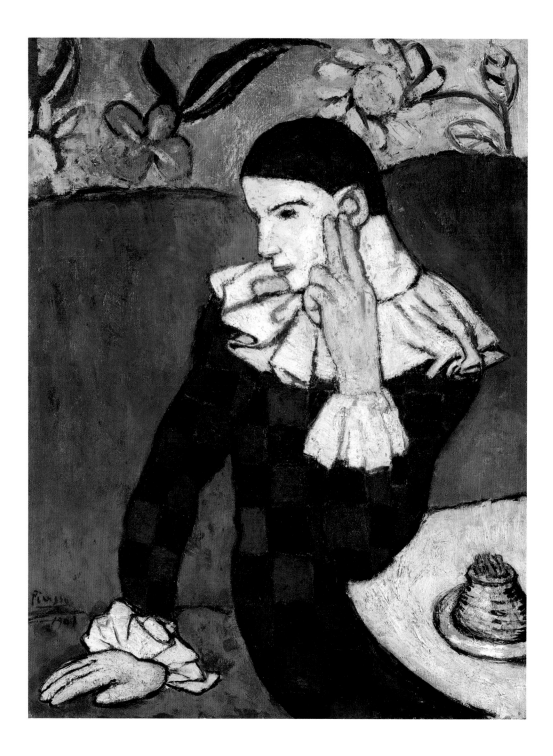

Pablo Picasso. Spanish, 1881–1973

Harlequin 1901
Oil on canvas
32 5/8 x 24 1/8 in. (82.7 x 61.2 cm)

Gift of Mr. and Mrs. John L. Loeb, 1960
60.87

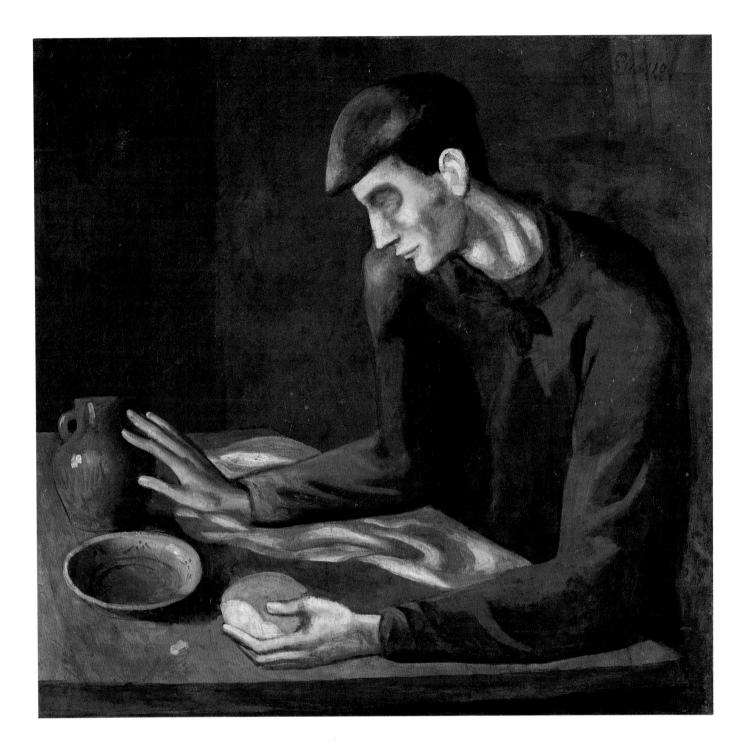

The Blind Man's Meal 1903
Oil on canvas
37 1/2 x 37 1/4 in. (95.3 x 94.6 cm)

Purchase, Mr. and Mrs. Ira Haupt Gift, 1950
50.188

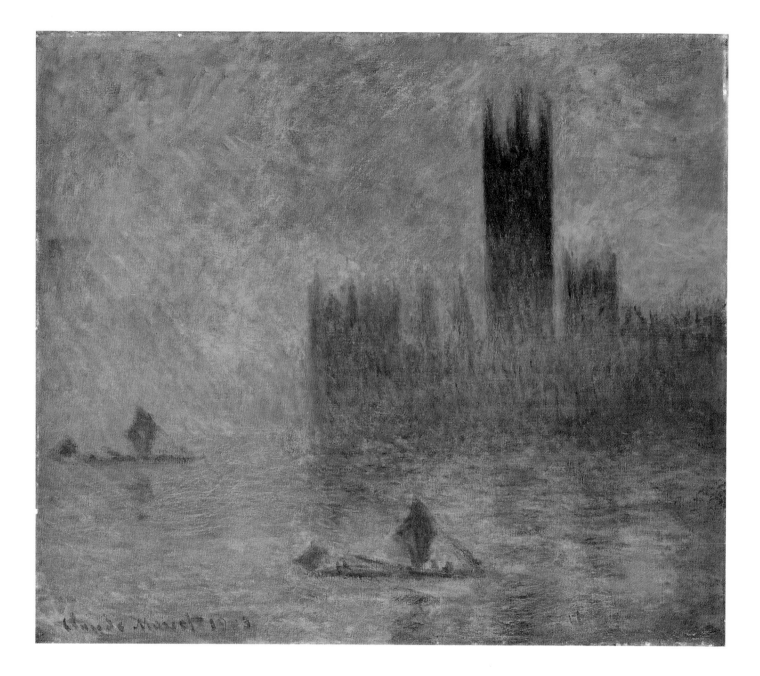

Claude Monet. French, 1840–1926

The Houses of Parliament Seen in Fog 1903
Oil on canvas
32 x 36 3/8 in. (81.3 x 92.4 cm)

Bequest of Julia W. Emmons, 1956
56.135.6

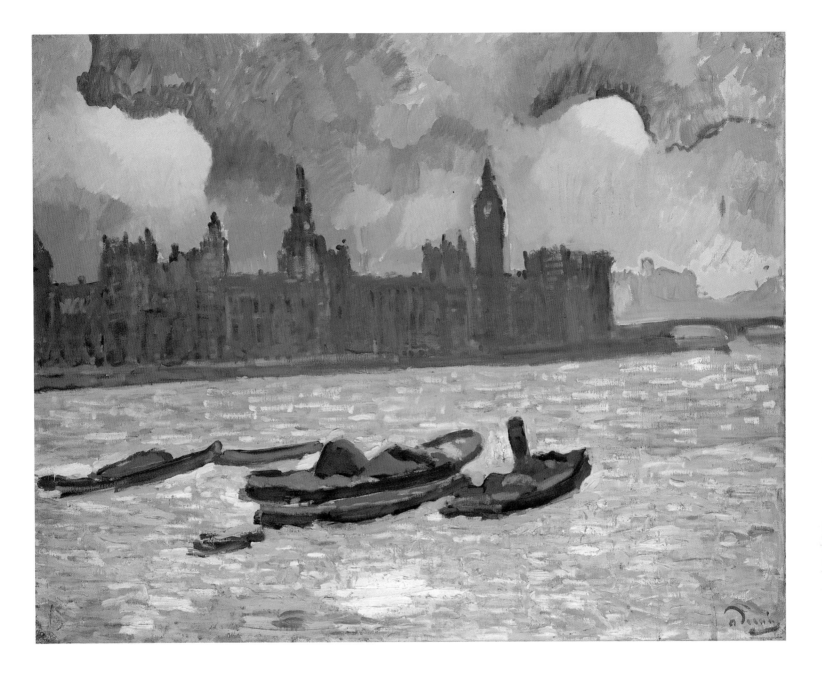

André Derain. French, 1880–1954

The Houses of Parliament Seen at Night 1906
Oil on canvas
40 1/2 x 47 3/4 in. (102.9 x 121.3 cm)

Robert Lehman Collection, 1975
1975.1.168

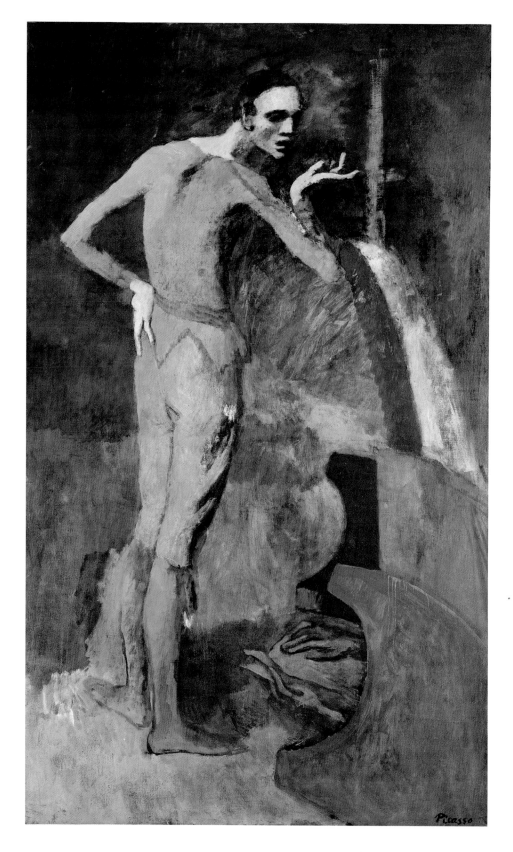

Pablo Picasso. Spanish, 1881–1973

The Actor Winter 1904–05
Oil on canvas
76 3/8 x 44 1/8 in. (194 x 112.1 cm)

Gift of Thelma Chrysler Foy, 1952
52.175

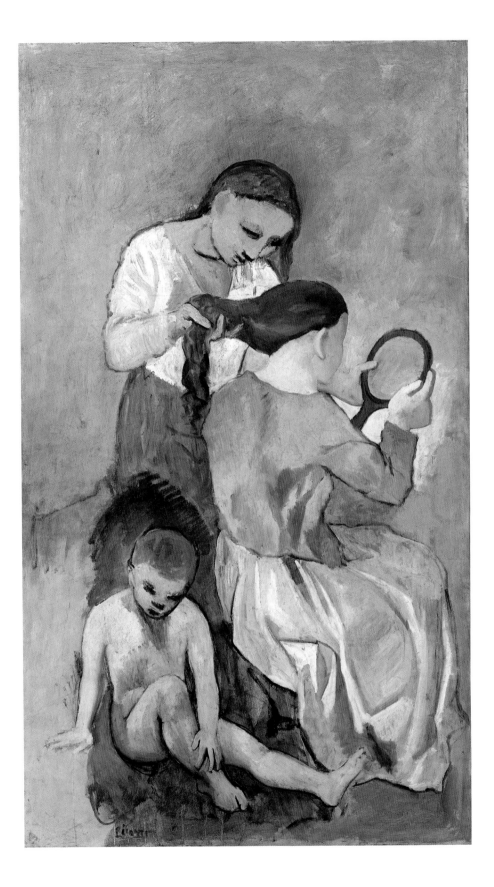

The Coiffure 1906
Oil on canvas
68 7/8 x 39 1/4 in. (174.9 x 99.7 cm)

Catharine Lorillard Wolfe Collection, Wolfe Fund, 1951; acquired
from The Museum of Modern Art, Anonymous Gift
53.140.3

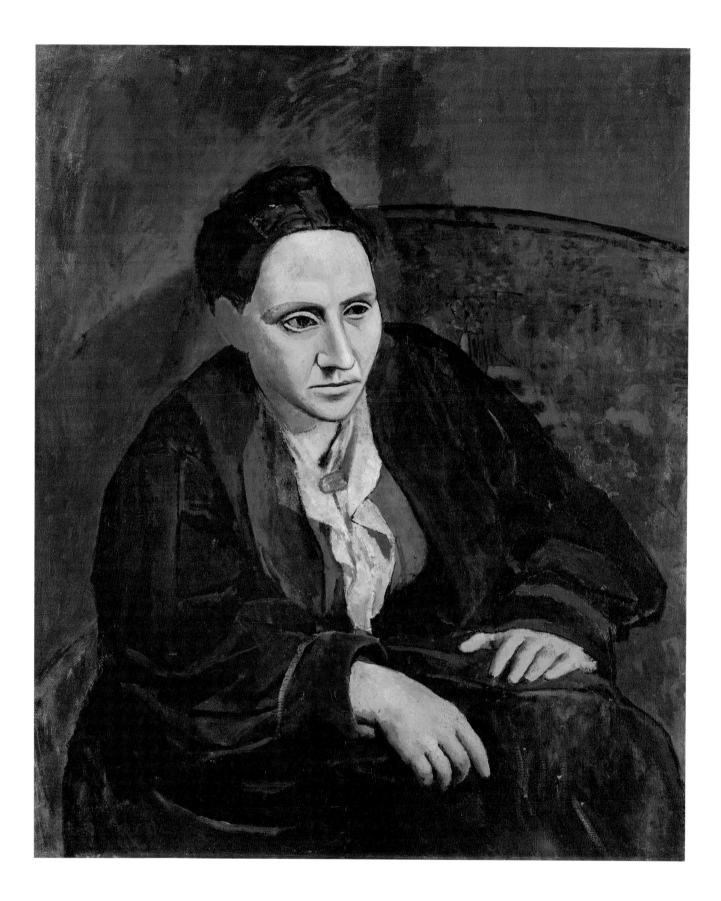

ALICE B. TOKLAS AND GERTRUDE STEIN'S PORTRAIT BY PICASSO

In New York on August 22, 1947, Gertrude Stein's portrait by Picasso was prominently placed on public view in the Great Hall of the Metropolitan Museum. A few months later, under a three-museum agreement, it was lent to the Museum of Modern Art.

In Paris the likeness very much remained Alice B. Toklas's concern. From the apartment that she had shared with Stein, she wrote the following six letters to officials of the Metropolitan:

–5 rue Christine VI–
–2–III–47–
[2 March 1947 to Charles S. Brown, the Museum's agent in Paris]

Dear Mr. Brown—
It is not only for the lovely flowers which fill the room with their radiance that I have to thank you—It touches me that you should have understood the sense of a new parting with my friend that suddenly overcame me—It wasn't the loss of the painting as a painting—nor the extraordinarily resembling portrayal of her—but there had been a strange exchange in of [sic] this early creative effort that she and Picasso felt had been expressed in the portrait. It was this [that] made it have so much meaning—I thank you again for your kindness—
Appreciatively gratefully,
Alice Toklas.

5 rue Christine VI Paris
15 IX 47
[15 September 1947 to Harry B. Wehle, curator of Paintings]

The Curator of Paintins [sic]
Metropolitain [sic] Museum of Art
New York

Dear Sir,
In your release to the press of August twenty-second, concerning the portrait of Gertrude Stein by Pablo Picasso, there are several inaccuracies.

The shipment of the picture was not delayed for several months in deference to my wish to keep it in its place here in the apartment as lomg [sic] as possible. On the contrary I instructed my lawyer to see that the museum take possession of the picture as soon as possible. After some delay the museum's representative telephoned to make arrangements for its removal. The following day when he called he said he was prepared to take the picture away with him at once. I asked him to give me a week's time to permit Picasso and some of Gertrude Stein's friends to see it for the last time. This was very grasiously [sic] immediately accorded The picture was not laned [sic] to the Museum of Modern Art's comprehensive show of Picasso in 1939. It has never left France until shipped this spring to the Metropolitain [sic] Museum of Art.

When the picture was commenced Gertrude Stein had been living in Paris a little over a year.

Gertrude Stein's first book was completed everal [sic] months before the portrait was.

Gertrude Stein never supported Braque.
Sincerely,
Alice Toklas

Pablo Picasso. Spanish, 1881–1973

Gertrude Stein 1906
Oil on canvas
39 3/8 x 32 in. (100 x 81.3 cm)

Bequest of Gertrude Stein, 1946
47.106

—5 rue Christine VI–Paris–
—6–X–47–
[6 October 1947 to Roland L. Redmond, president of the Museum]

Dear Sir—
C. D. Morgan Esquire has suggested that I should give you some details concerning Miss Gertrude Stein's bequest to the Metropolitan Museum of Art of her portrait by Picasso. Miss Gertrude Stein very deliberately chose the Metropolitan Museum—having decided to leave the picture to a museum in her mind there was no choice—if there had been one the Museum of Modern Art would not have been an alternative. . . . It is now very sad to see her wishes so disregarded—so miscarried. It is an ethical question. And I appeal to you to reconsider your decision to lend the picture to the Museum of Modern Art taking into account her opinions and feelings and to make these clear to the other trustees of the Metropolitan Museum and to ask them to change their decision—so that the painting remains at the Metropolitan Museum—
Yours very sincerely,
Alice Toklas

—5 rue Christine–Paris VI–
—22–III–48.
[22 March 1948 to Dudley T. Easby Jr., secretary to the Board of Trustees]

Dear Mr. Easby,
Thank you so much for sending me the official certificate declaring Gertrude Stein a benefactor of the museum—May I ask you to convey to the trustees my deep appreciation—I would also ask you to kindly say to them how much this recognition of her bequest touches me.
I have still the hope of seeing the portrait returned to the museum—though I fear it will require a considerable convulsion [?] before that can be achieved.
Thank you for your good wishes. Pray accept mine for yourself and for the museum.
Cordially
Alice Toklas

—5 rue Christine VI–Paris–
—7–I–50.
[7 January 1950 to Robert Beverly Hale, associate curator of Paintings and Sculpture]

My dear Mr. Hale,
A letter from Mrs. [Dorothy] Harvey the day before Christmas brought me the best news I'll ever here [sic] that you had just told her that the Picasso portrait of Gertrude Stein was definitely being returned to the Metropolitan. Before there was time to get your address which unfortunately had been mislaid a letter has reached me that it is hanging there amongst the French pictures and that it looks magnificent in a room freshly painted and recently rehung—What you have accomplished—and please believe I am not insensible of the serious difficulty you had to overcome gives me a peace of mind that I have not known for three years—I am deeply grateful to you and thank you with all my heart.
It would be a pleasure for me to think that sometime—now or later—that there is some service I could render you and that you would not hesitate to let me know—and that sometime when you come to Paris you would permit me to thank you à vive voix.
Always appreciatively—gratefully
Alice Toklas—

5 rue Christine VI–Paris–
Easter Sunday–1950.
[Easter Sunday 1950 to Theodore Rousseau Jr., associate curator of Paintings]

My dear Mr. Rousseau.
Thank you so much for your kindness in sending me a photograph of the portrait by Picasso in the newly installed
French room. You will understand how much it means to me to have such pleasant proof of its being finally—and let
us hope permanently—where Gertrude Stein intended it to be.
Cordially
A.B. Toklas.

.

Alice B. Toklas died in 1967. The last time she saw Picasso's portrait was in Paris in 1955, when
the painting had been lent to the Louvre.

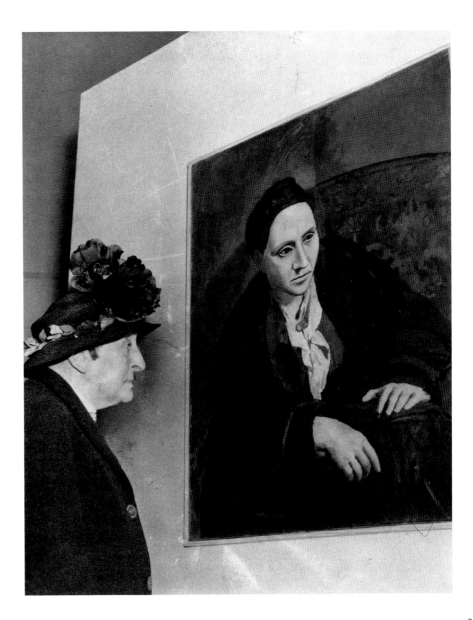

Alice B. Toklas looking at
Picasso's portrait of Gertrude
Stein, Paris, 1955

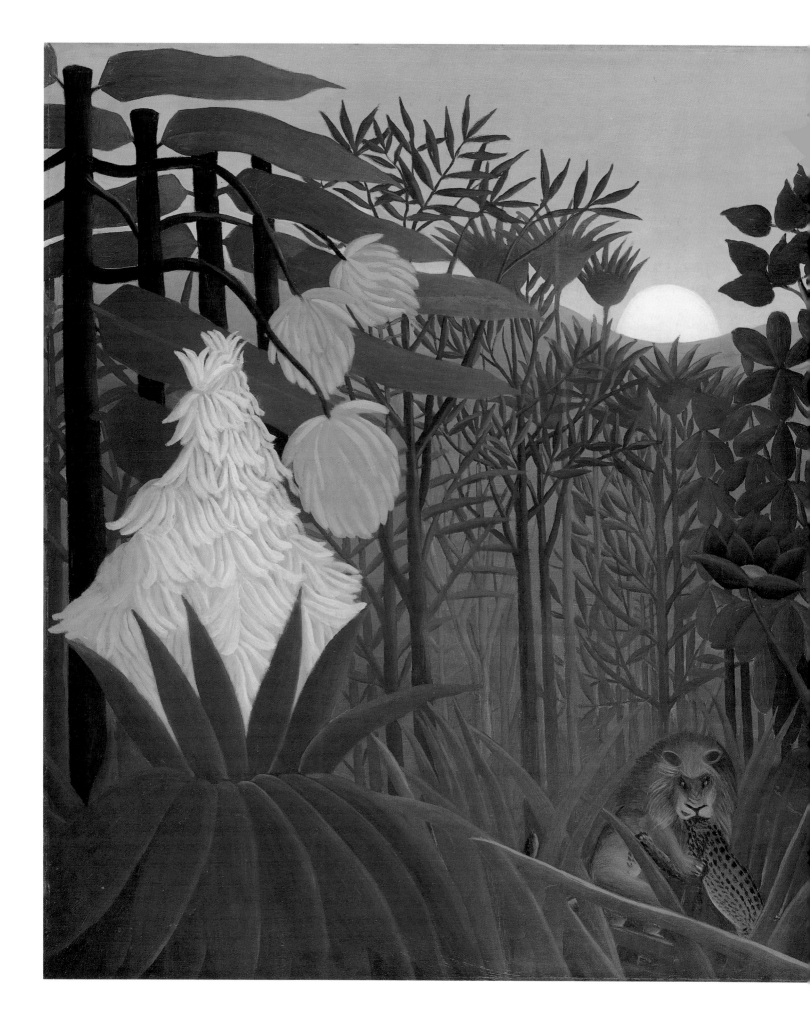

Henri Rousseau. French, 1844–1910

The Repast of a Lion ca. 1907
Oil on canvas
44 3/4 x 63 in. (113.7 x 160 cm)

Bequest of Sam A. Lewisohn, 1951
51.112.5

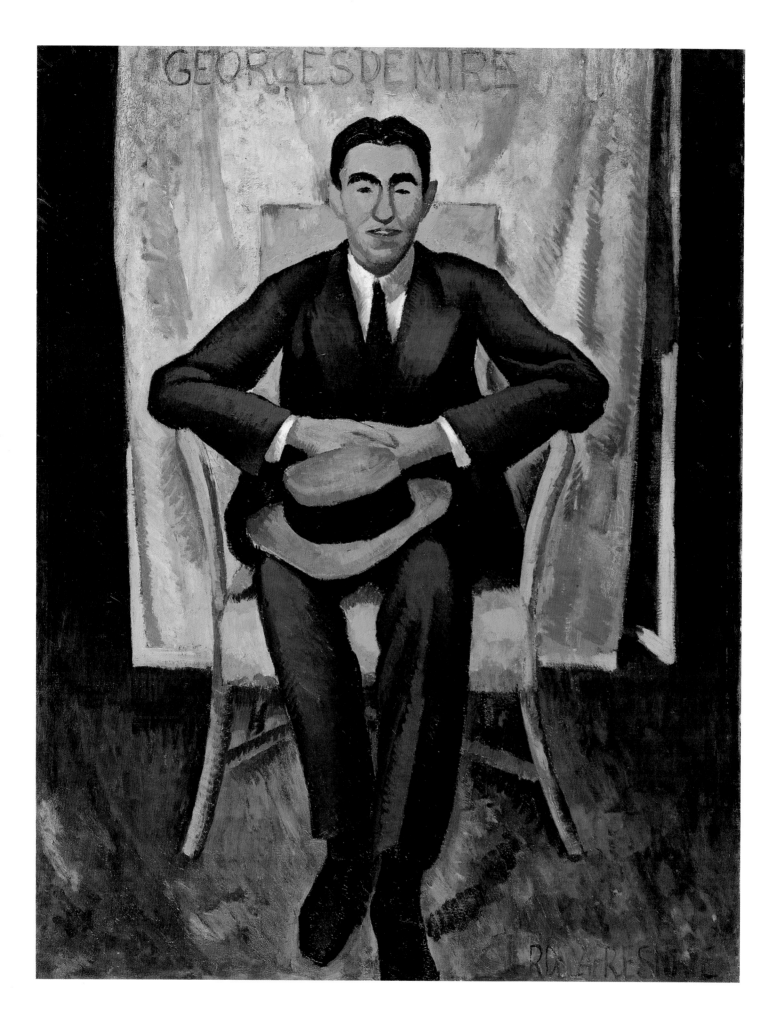

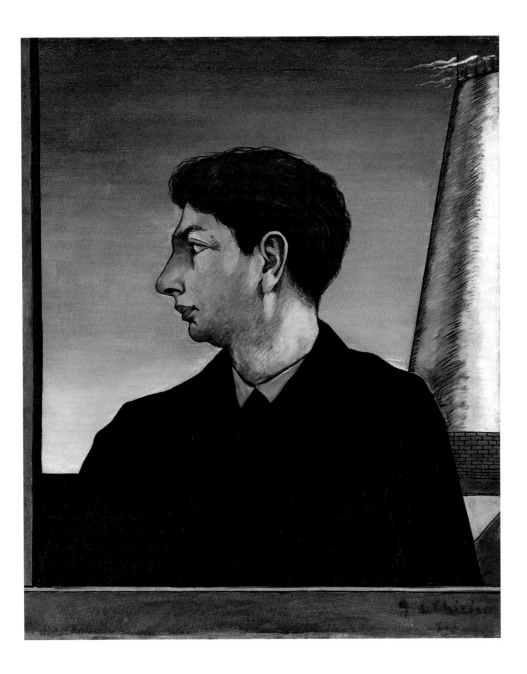

Roger de La Fresnaye. French, 1885–1925

Georges de Miré 1910
Oil on canvas
50 3/4 x 38 1/2 in. (128.9 x 97.8 cm)

Gift of Mr. and Mrs. Nathan Cummings, 1962
62.261

Giorgio de Chirico. Italian, 1888–1978

Self-Portrait 1911
Oil on canvas
34 3/8 x 27 1/2 in. (87.3 x 69.9 cm)

Gift in memory of Carl Van Vechten and Fania
Marinoff, 1970
1970.166

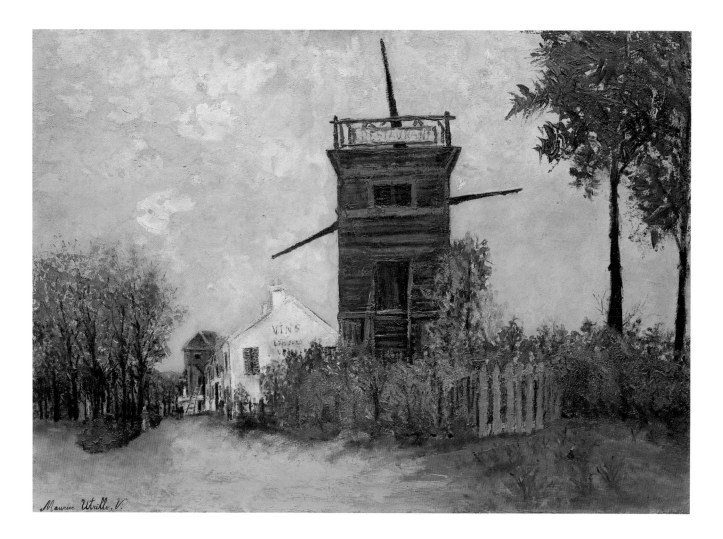

Maurice Utrillo. French, 1883–1955

The Old Windmill at Sannois 1911
Oil on cardboard
21 1/8 x 25 5/8 in. (53.7 x 65.1 cm)

Bequest of Miss Adelaide Milton de Groot (1876–1967), 1967
67.187.110

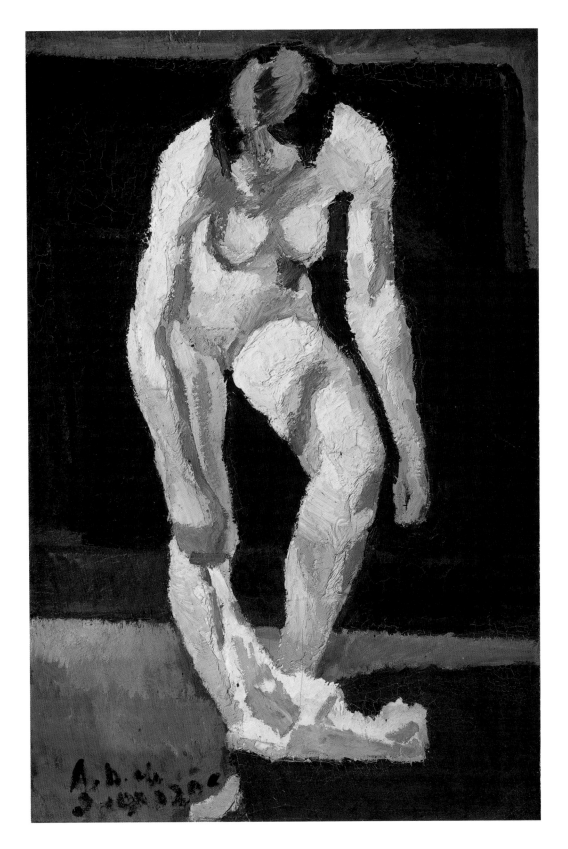

André Dunoyer de Segonzac. French, 1884–1974

Model Dressing 1912
Oil on canvas
39 3/8 x 25 5/8 in. (100 x 65.1 cm)

Bequest of Miss Adelaide Milton de Groot (1876–1967), 1967
67.187.100

André Derain. French, 1880–1954

The Table 1911
Oil on canvas
38 x 51 5/8 in. (96.5 x 131.1 cm)

Catharine Lorillard Wolfe Collection, Wolfe Fund, 1954
54.79

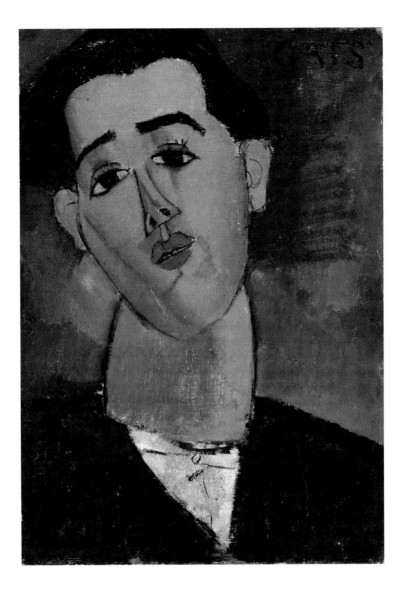

Amedeo Modigliani. Italian, 1884–1920

Juan Gris 1915
Oil on canvas
21 5/8 x 15 in. (54.9 x 38.1 cm)

Bequest of Miss Adelaide Milton de Groot (1876–1967), 1967
67.187.85

33

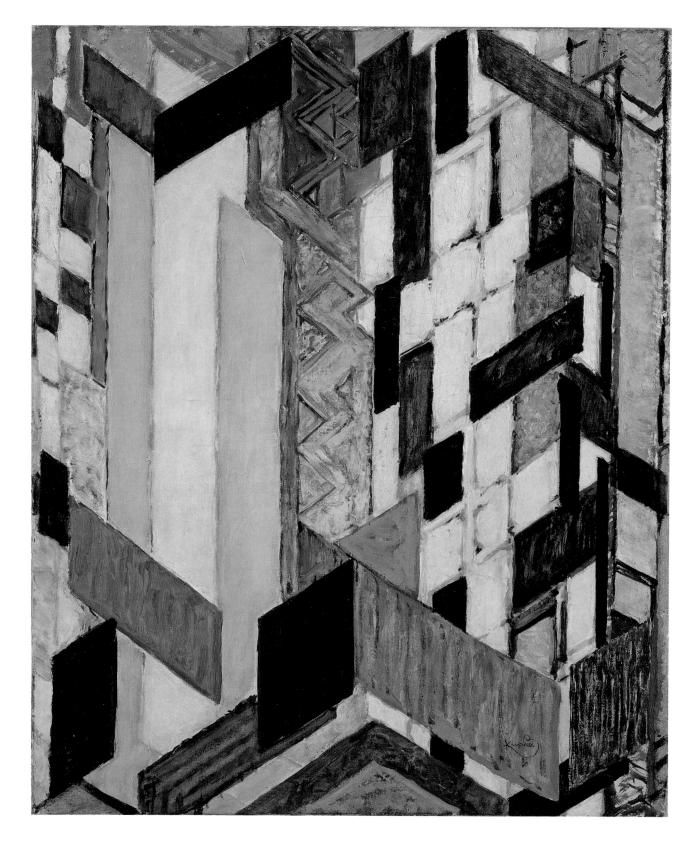

František Kupka. Czech, 1871–1957

Vertical and Diagonal Planes ca. 1913–14
Oil on canvas
24 1/8 x 19 3/4 in. (61.3 x 50.2 cm)

Gift of Joseph H. Hazen Foundation Inc., 1971
1971.111

34

Natalia Gontcharova. French, born Russia, 1881–1962

Decor for the Ballet "Liturgie" 1915
Watercolor, pencil, cut and pasted paper, silver, gold, and
colored foil on cardboard
21 3/4 x 29 3/8 in. (55.2 x 74.6 cm)

Gift of the Humanities Fund Inc., 1972
1972.146.10

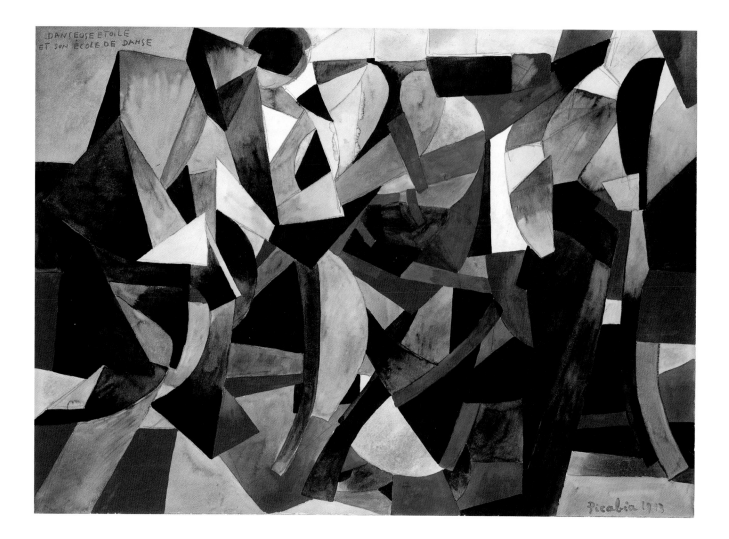

Francis Picabia. French, 1879–1953

Star Dancer with Her Dance School 1913
Watercolor on paper
22 x 30 in. (55.6 x 76.2 cm)

Alfred Stieglitz Collection, 1949
49.70.12

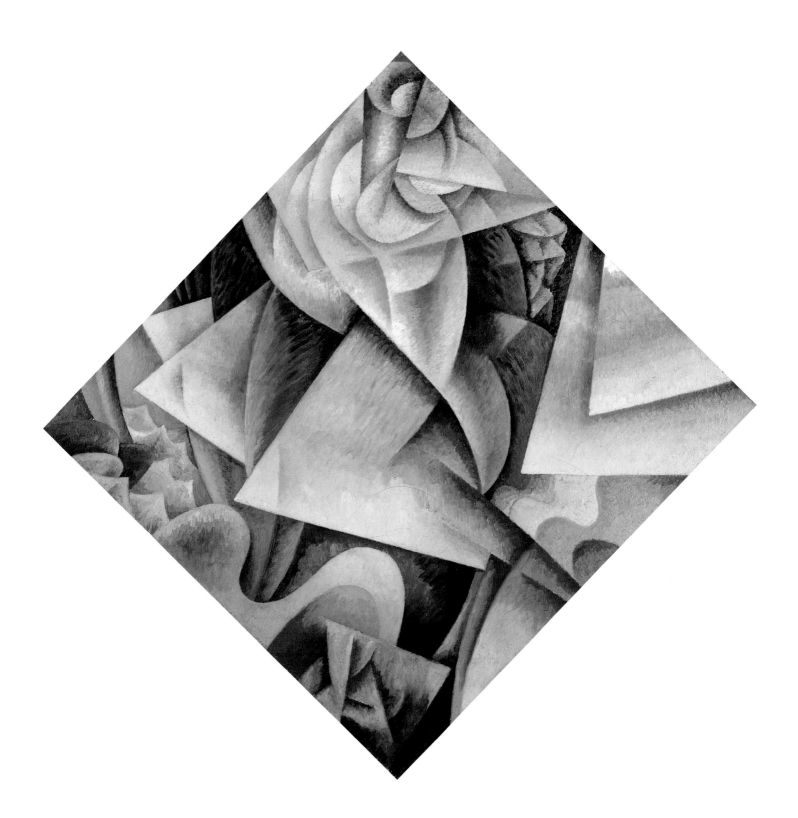

Gino Severini. Italian, 1883–1966

Dancer-Airplane Propeller-Sea 1915
Oil on canvas
29 5/8 x 30 3/4 in. (75.2 x 78.1 cm)

Alfred Stieglitz Collection, 1949
49.70.3

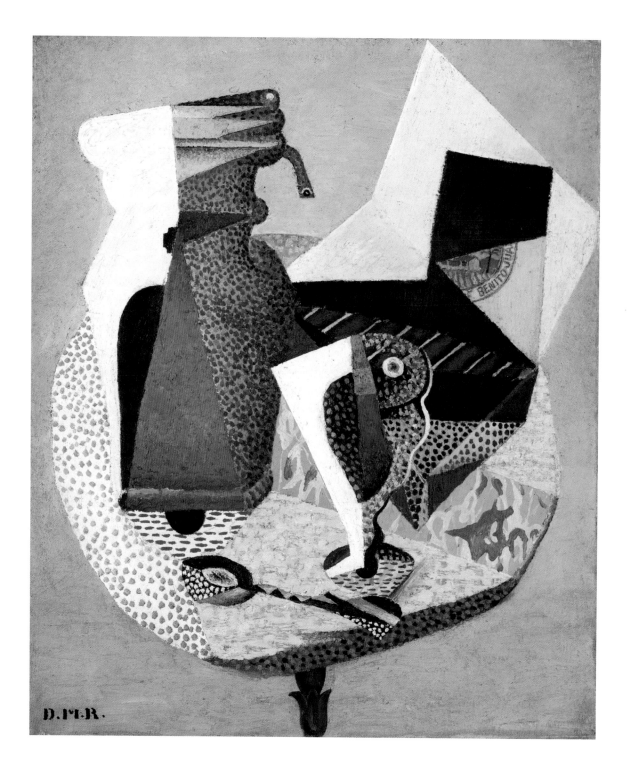

Diego Rivera. Mexican, 1886–1957

Table on a Café Terrace 1915
Oil on canvas
23 7/8 x 19 1/2 in. (60.6 x 49.5 cm)

Alfred Stieglitz Collection, 1949
49.70.51

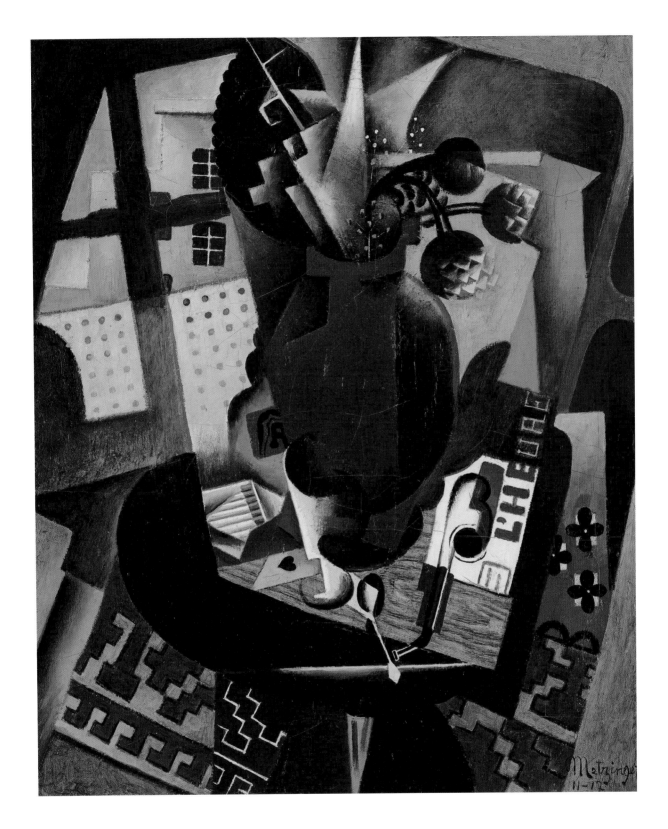

Jean Metzinger. French, 1883–1956

Table by a Window November 1917
Oil on canvas
32 x 25 5/8 in. (81.5 x 65.1 cm)

Purchase, The M.L. Annenberg Foundation, Joseph H. Hazen
Foundation Inc., and Joseph H. Hazen Gifts, 1959
59.86

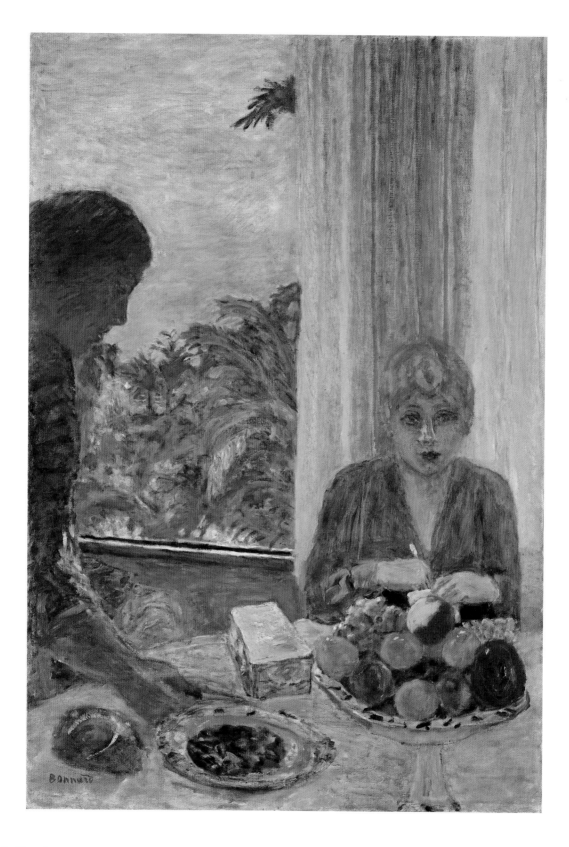

Pierre Bonnard. French, 1867–1947

The Green Blouse 1919
Oil on canvas
40 1/8 x 26 7/8 in. (101.9 x 68.3 cm)

The Mr. and Mrs. Henry Ittleson Jr. Purchase Fund, 1963
63.64

40

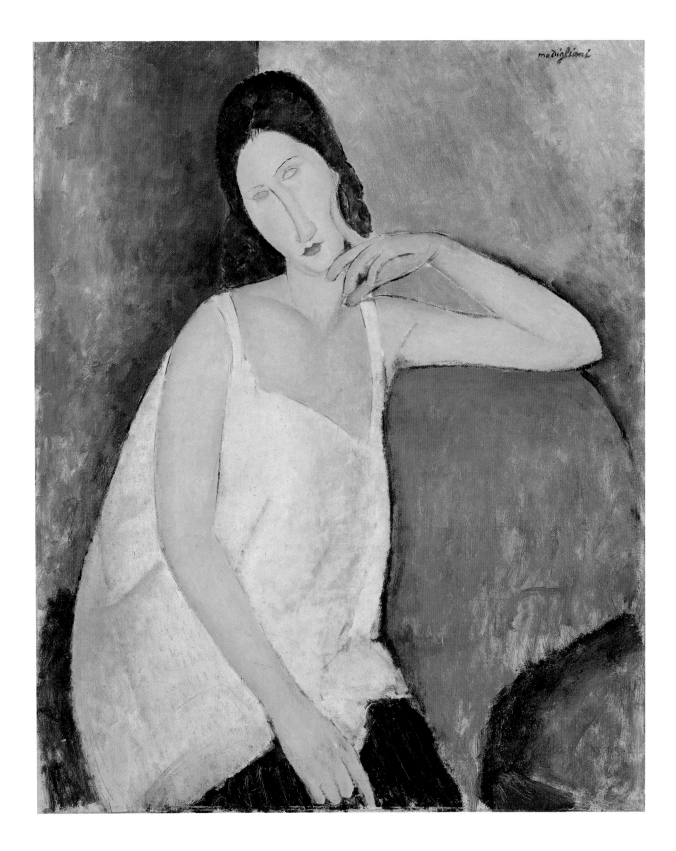

Amedeo Modigliani. Italian, 1884–1920

Jeanne Hébuterne 1919
Oil on canvas
36 x 28 3/4 in. (91.4 x 73 cm)

Gift of Mr. and Mrs. Nate B. Spingold, 1956
56.184.2

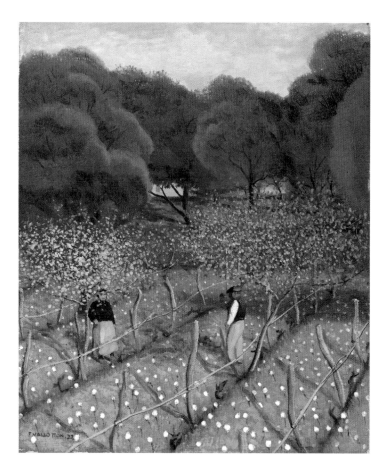

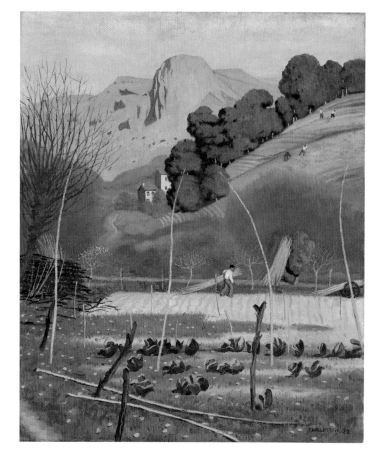

Félix Vallotton. Swiss, 1865–1925

Flowering Peach Trees, Provence 1922
Oil on canvas
28 3/4 x 23 3/4 in. (73 x 60.3 cm)

Bequest of Miss Adelaide Milton de Groot (1876–1967), 1967
67.187.114

Landscape at Saint Jeannet, Provence 1922
Oil on canvas
31 3/4 x 25 1/2 in. (80.6 x 64.8 cm)

Bequest of Miss Adelaide Milton de Groot (1876–1967), 1967
67.187.115

Edouard Vuillard. French, 1868–1940

Morning in the Garden at Vaucresson 1923 and 1937
Distemper on canvas
59 1/2 x 43 5/8 in. (151.2 x 110.8 cm)

Catharine Lorillard Wolfe Collection, Wolfe Fund, 1952
52.183

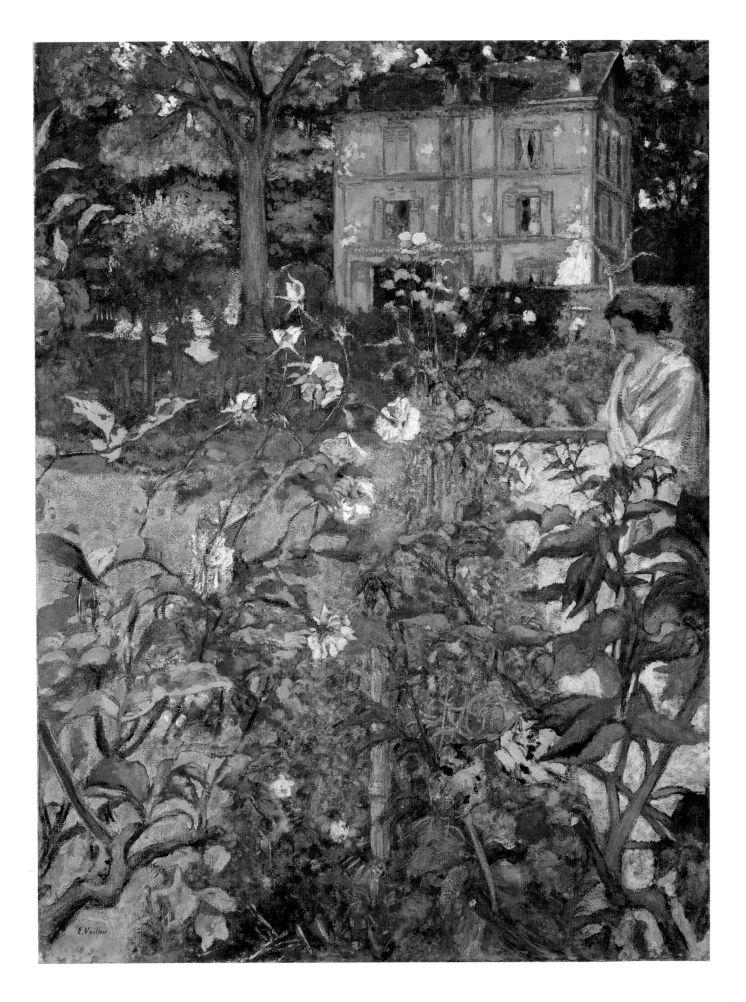

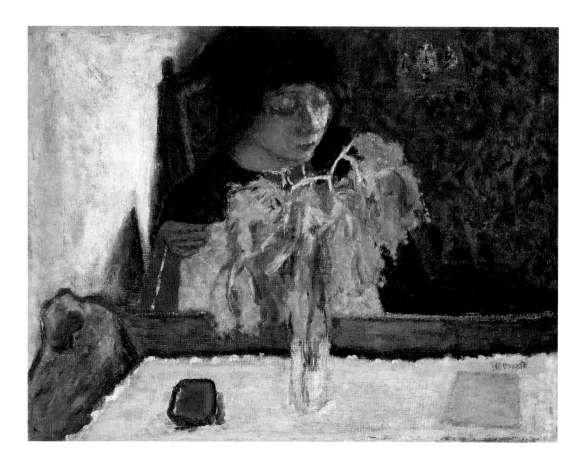

Pierre Bonnard. French, 1867–1947

Woman with Mimosa 1924
Oil on canvas
19 1/8 x 24 5/8 in. (48.5 x 62.5 cm)

Bequest of Ann Eden Woodward
(Mrs. William Woodward Jr.), 1975
1978.264.8

Pablo Picasso. Spanish, 1881–1973

Woman in White 1923
Oil on canvas
39 x 31 1/2 in. (99.1 x 80 cm)

Rogers Fund, 1951; acquired from The Museum of
Modern Art, Lillie P. Bliss Collection
53.140.4

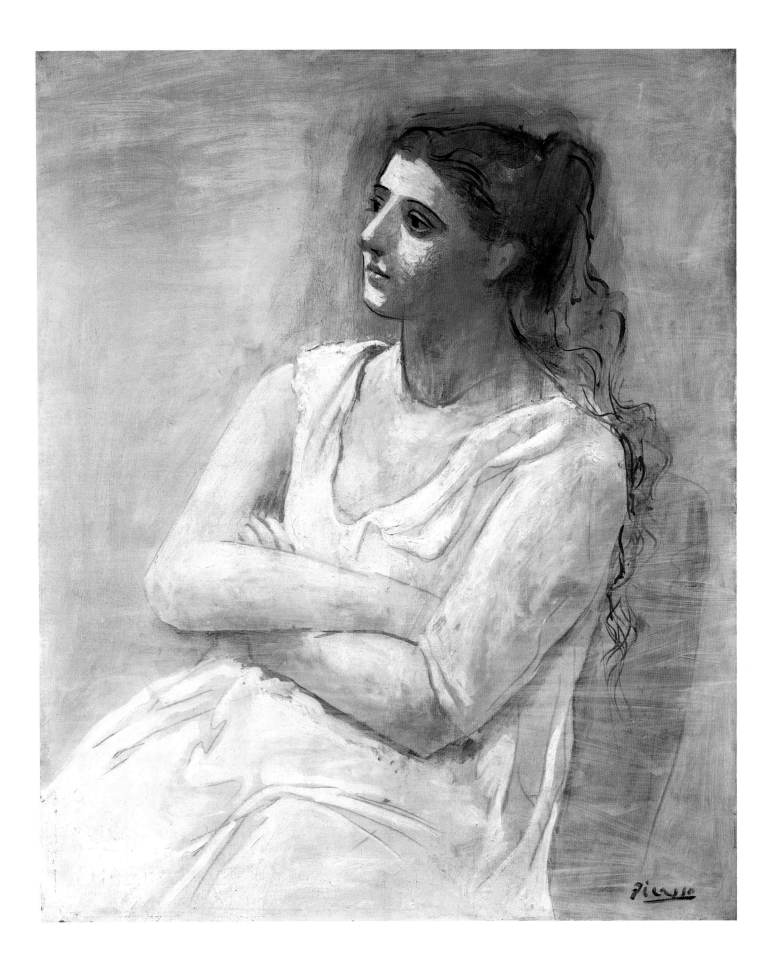

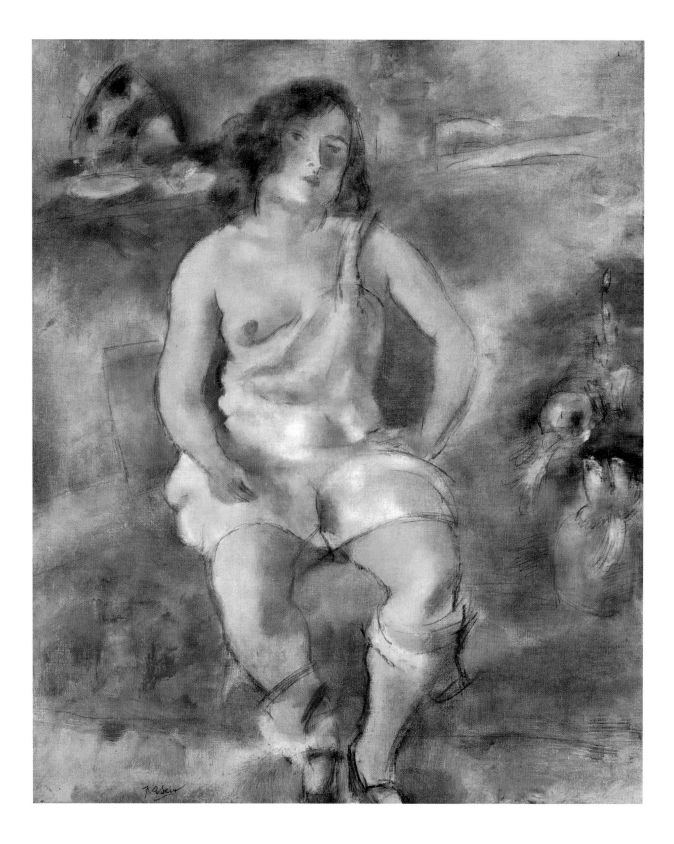

Jules Pascin. American, born Bulgaria, 1885–1930

Seated Model 1925
Oil on canvas
39 1/2 x 32 in. (100.3 x 81.3 cm)

Bequest of Miss Adelaide Milton de Groot (1876–1967), 1967
67.187.168

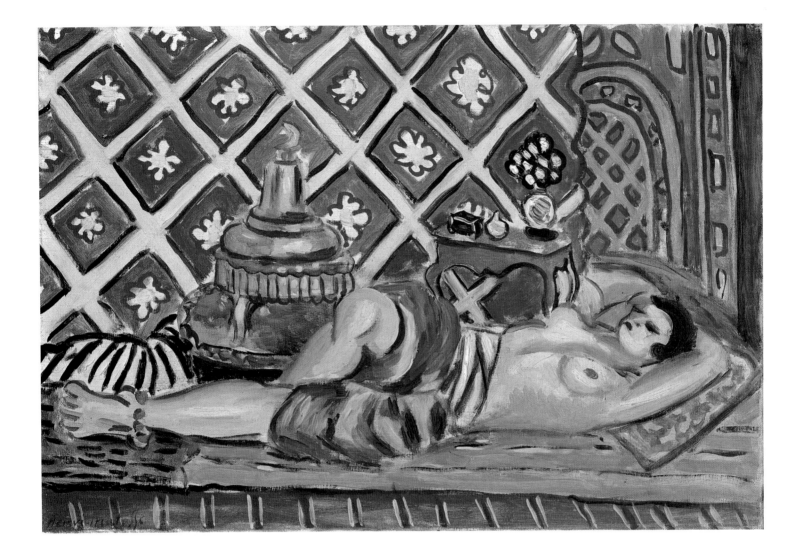

Henri Matisse. French, 1869–1954

Reclining Odalisque 1926
Oil on canvas
15 1/8 x 21 5/8 in. (38.4 x 54.9 cm)

Bequest of Miss Adelaide Milton de Groot (1876–1967), 1967
67.187.82

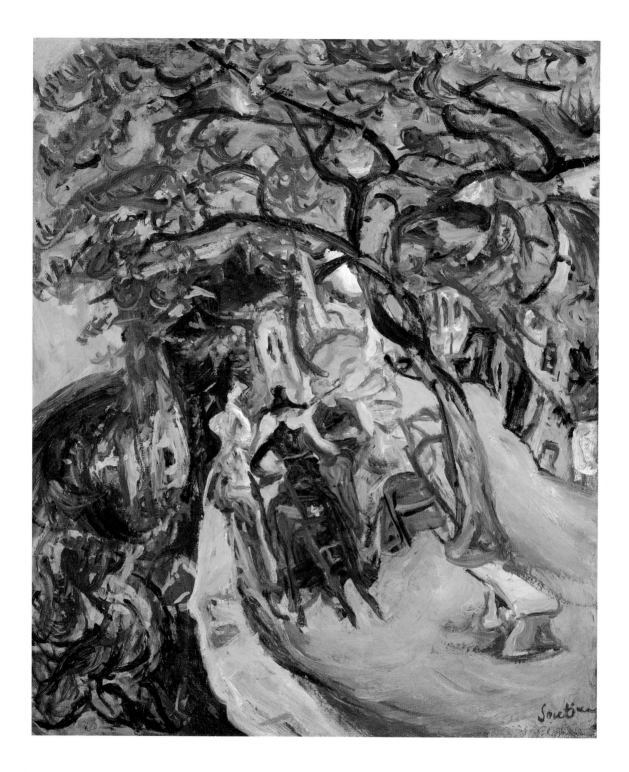

Chaim Soutine. French, born Lithuania, 1893–1943

The Terrace at Vence ca. 1922
Oil on canvas
24 1/2 x 19 3/4 in. (62.2 x 50.2 cm)

Gift of Hon. and Mrs. Peter I. B. Lavan, 1964
64.147

Madeleine Castaing ca. 1929
Oil on canvas
39 3/8 x 28 7/8 in. (100 x 73.3 cm)

Bequest of Miss Adelaide Milton de Groot (1876–1967), 1967
67.187.107

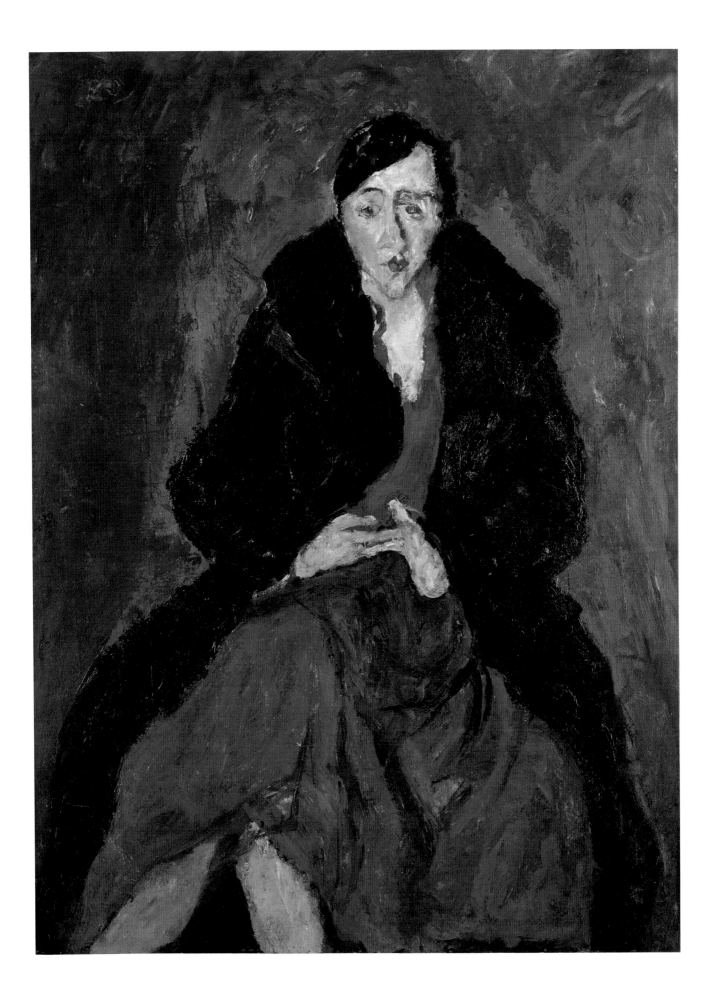

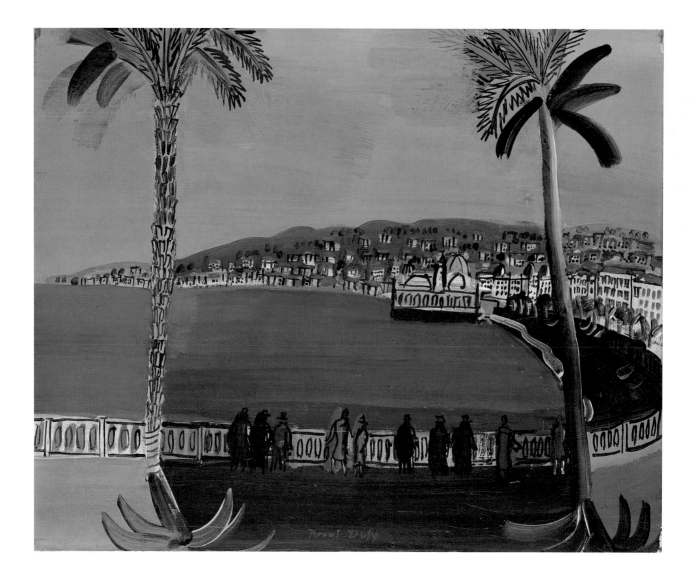

Raoul Dufy. French, 1877–1953

Dusk at La Baie des Anges, Nice 1932
Oil on canvas
14 7/8 x 18 in. (37.8 x 45.7 cm)

Bequest of Miss Adelaide Milton de Groot (1876–1967), 1967
67.187.67

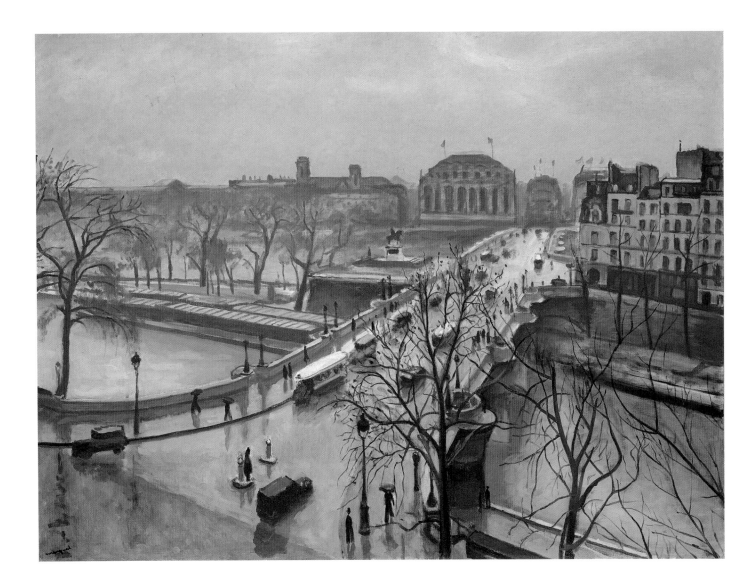

Albert Marquet. French, 1875–1947

The Pont Neuf, Paris 1935
Oil on canvas
35 x 45 3/4 in. (88.9 x 116.2 cm)

Gift of Mrs. Charles S. Payson, 1966
66.5

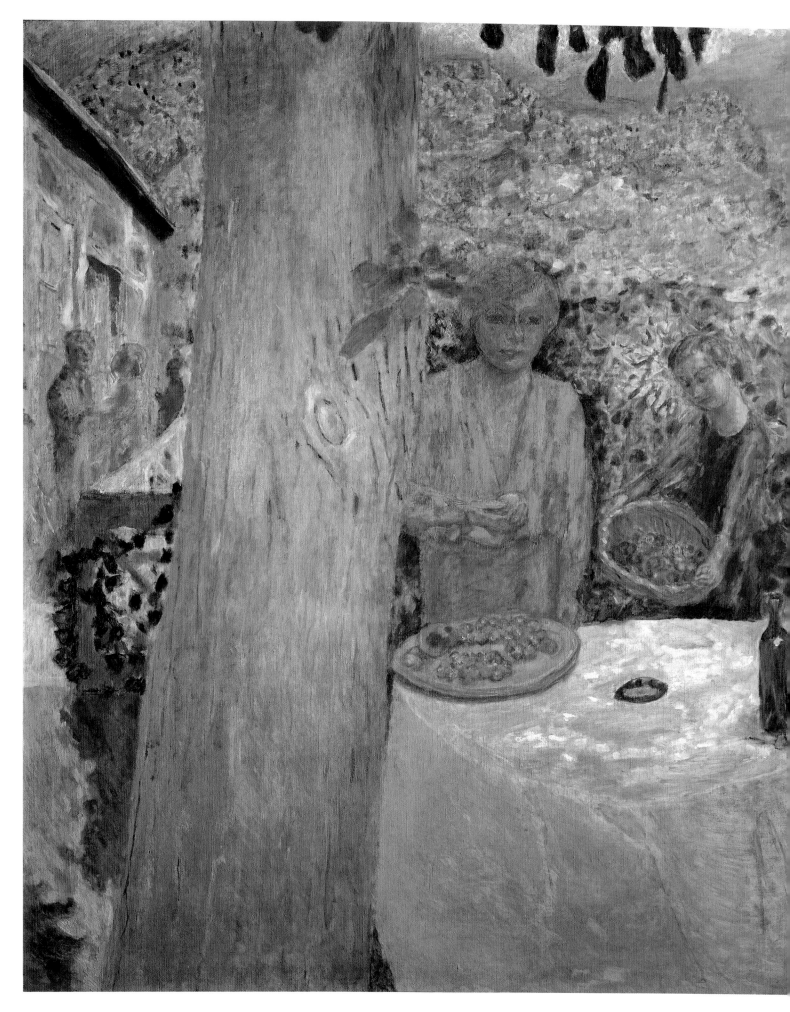

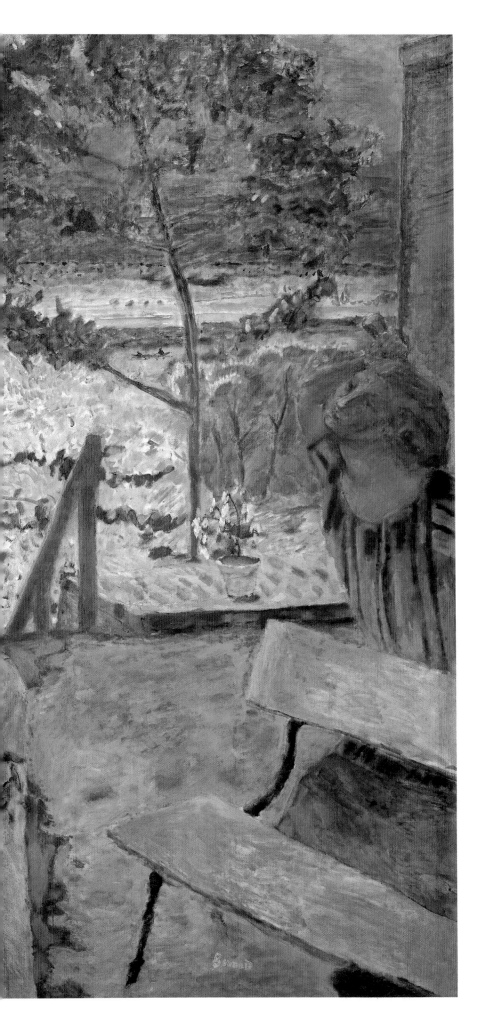

Pierre Bonnard. French, 1867–1947

The Terrace at Vernonnet 1939
Oil on canvas
58 1/4 x 76 3/4 in. (148 x 194.9 cm)

Gift of Mrs. Frank Jay Gould, 1968
68.1

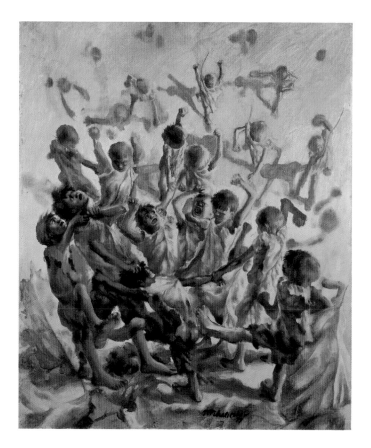 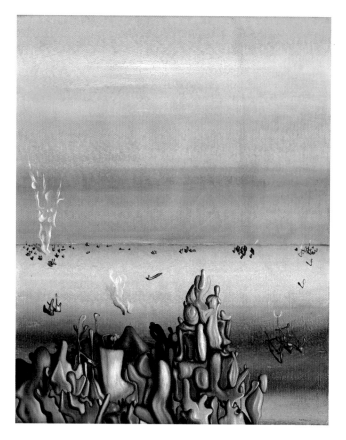

Pavel Tchelitchew. American, born Russia, 1898–1957

The Whirlwind 1939
Oil on canvas
28 1/2 x 23 3/4 in. (72.4 x 60.3 cm)

Arthur Hoppock Hearn Fund, 1950
50.38

Yves Tanguy. American, born France, 1900–1955

The Hostages 1934
Oil on canvas
25 1/2 x 19 3/4 in. (64.8 x 50.2 cm)

Bequest of Kay Sage Tanguy, 1963
66.8.1

The Mirage of Time 1954
Oil on canvas
39 x 32 in. (99.1 x 81.3 cm)

George A. Hearn Fund, 1955
55.95

PAINTERS IN PARIS
1895-1950

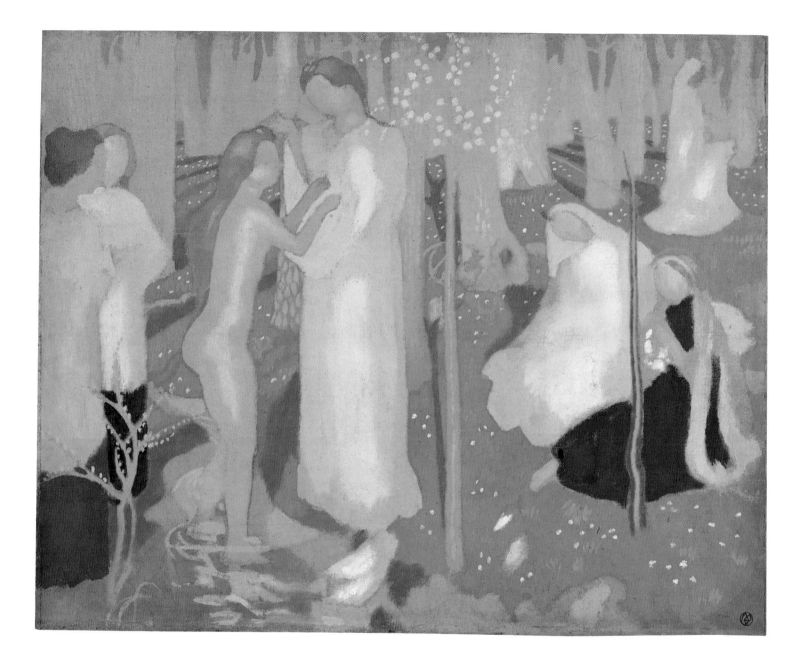

ACQUISITIONS 1979–1999

Among the followers of Gauguin, and particularly influenced by the decorative and flattened patterns of his religious pictures painted in Brittany, were Bonnard, Vuillard, and Denis. After Gauguin quit France, these younger painters briefly considered Redon as mentor.

In their paintings Bonnard and Vuillard recorded moments of bourgeois daily life; Denis, a devout Catholic, was less interested in quotidian detail, and he sought instead the spiritual in art. For a decade these artists exchanged ideas, and they called themselves the "Nabis," the Hebrew word for prophet. Bonnard and Vuillard subsequently adapted an Impressionist mode; Denis remained faithful to the Nabis ideal. His *Springtime*, at the left, gift of David Allen Devrishian, was acquired by the Museum in 1999. It is the first painting by Denis to enter the collection, and Mr. Devrishian is also the donor of Bonnard's *The Children's Meal* reproduced on the next page. It should be remembered that the Nabis were contemporaries of Matisse and that Picasso was born a decade later in 1881, a few months before Braque, his companion in Cubism.

During recent years the gifts of four large collections considerably augmented the Museum's representation of the School of Paris: the bequest of Scofield Thayer in 1982; the bequest of Florene M. Schoenborn in 1995; the gifts of Mr. and Mrs. Klaus G. Perls in 1997 and 1998; and, most recently, in 1998, the bequest of Natasha Gelman of the collection she assembled with her husband, Jacques Gelman. Nine of the paintings are illustrated here. These four collections complement each other, and thus the work of certain artists can now be appreciated in depth. Other major gifts included Louise Reinhardt Smith's late nymphaeas by Monet and her elegant still life by Braque, as well as Mr. and Mrs. Allan D. Emil's bequest of a Balthus portrait and Léger's heraldic three women. It is possible to include only one of Muriel Kallis Newman's promised gifts, Ernst's startling likeness of Dali's muse when she was wife of the French poet Paul Eluard. Among Mrs. Newman's other promised gifts are a painting by Léger and one by Miró.

"Painters in Paris: 1895–1950" might be followed by a complementary exhibition also selected from the Museum's collection. "Drawings by Artists of the School of Paris" would offer a similar survey in a different medium.

Only three painters represented in this visual chronicle were born after 1900: Dubuffet, who died in 1985; Hélion, who died in 1987; and Balthus, who is alive today. With them, the School of Paris ends, and its heroic years had already passed.

· · · · · · ·

The generosity of friends of the Museum has been extraordinary. Among the sixty-three recent acquisitions reproduced here, only four were purchases: both landscapes by Balthus, Derain's *Fishing Boats, Collioure*, and Villon's *The Dining Table*.

The exhibition "Painters in Paris: 1895–1950" consists of more than 100 paintings by 38 artists acquired by the Museum since 1947. This selection is not a complete survey of the School of Paris, and much is still lacking. For instance, paintings of the period and place by Dali, Duchamp, Giacometti, and Masson are not yet in the collection. Additional gifts from the Gelman bequest may remedy some but not all such lacunae. The Museum will continue to rely upon its trustees, curators, and friends.

A growing collection can never be complete.

Maurice Denis. French, 1870–1943

Springtime ca. 1897
Oil on canvas
31 3/4 x 38 1/2 in. (80.6 x 97.8 cm)

Gift of David Allen Devrishian, 1999
1999.180.2a

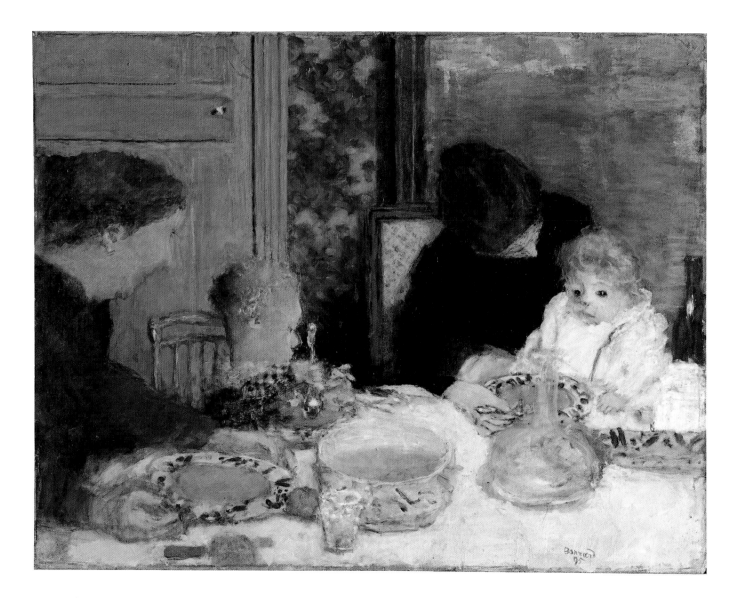

Pierre Bonnard. French, 1867–1947

The Children's Meal 1895
Oil on canvas
23 3/8 x 29 3/8 in. (59.4 x 74.6 cm)

Gift of David Allen Devrishian, 1999
1999.180.1

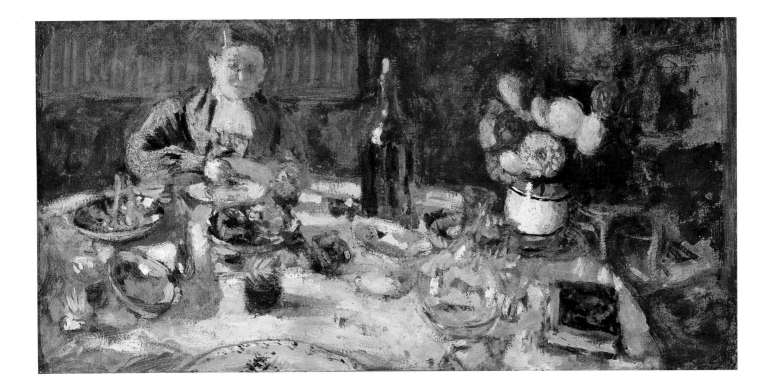

Edouard Vuillard. French, 1868–1940

Luncheon 1901
Oil on cardboard
8 3/4 x 17 in. (22.2 x 43.2 cm)

Bequest of Mary Cushing Fosburgh, 1978
1979.135.28

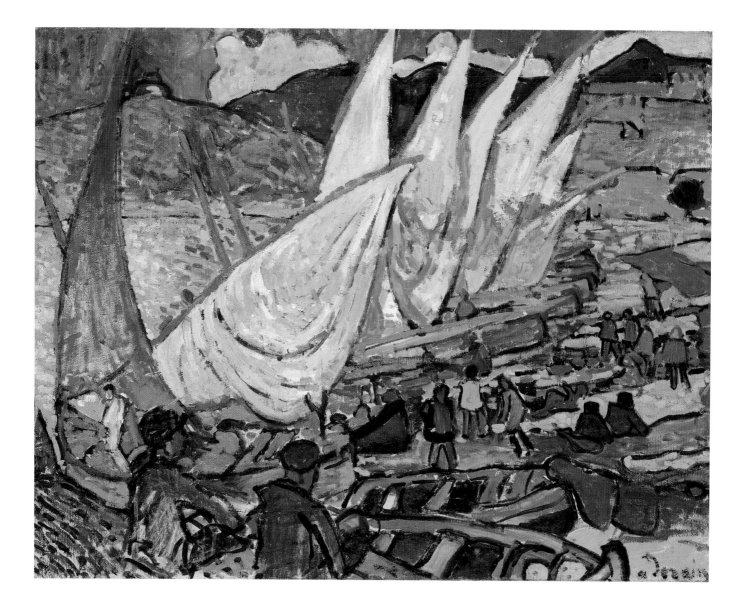

André Derain. French, 1880–1954

Fishing Boats, Collioure 1905
Oil on canvas
31 7/8 x 39 1/2 in. (81 x 100.3 cm)

Gift of Raymonde Paul, in memory of her brother, C. Michael Paul,
and Purchase, Lila Acheson Wallace Gift, 1982
1982.179.29

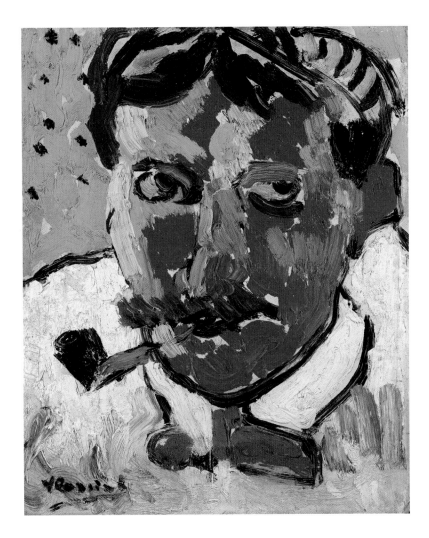

Maurice de Vlaminck. French, 1876–1958

André Derain 1906
Oil on cardboard
10 5/8 x 8 3/4 in. (27 x 22.2 cm)

Jacques and Natasha Gelman Collection, 1998
1999.363.83

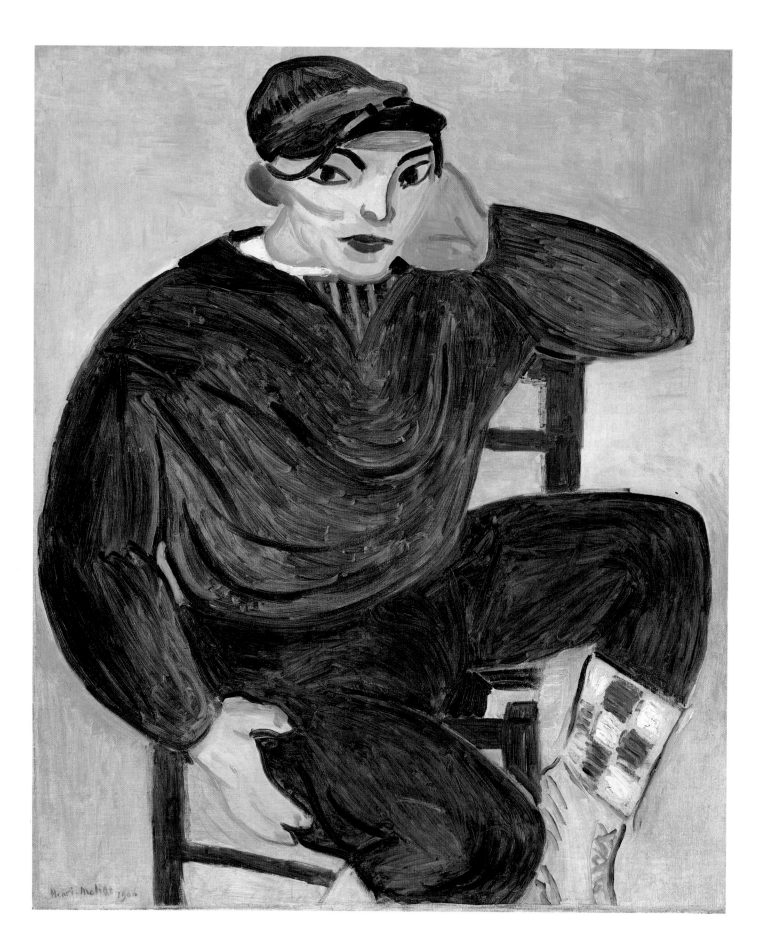

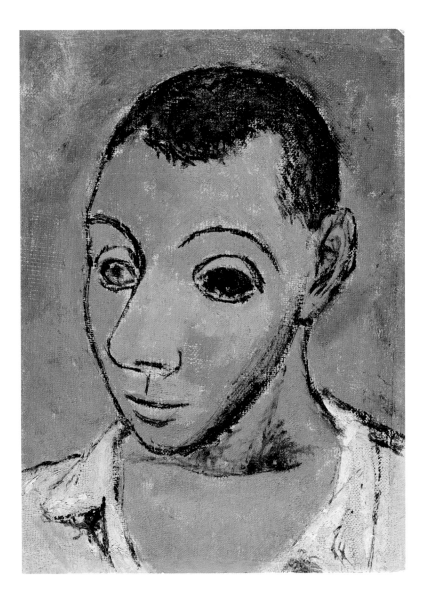

Henri Matisse. French, 1869–1954

The Young Sailor II 1906
Oil on canvas
40 x 32 3/4 in. (101.5 x 83 cm)

Jacques and Natasha Gelman Collection, 1998
1999.363.41

Pablo Picasso. Spanish, 1881–1973

Self-Portrait 1906
Oil on canvas mounted on wood
10 1/2 x 7 3/4 in. (26.7 x 19.7 cm)

Jacques and Natasha Gelman Collection, 1998
1999.363.59

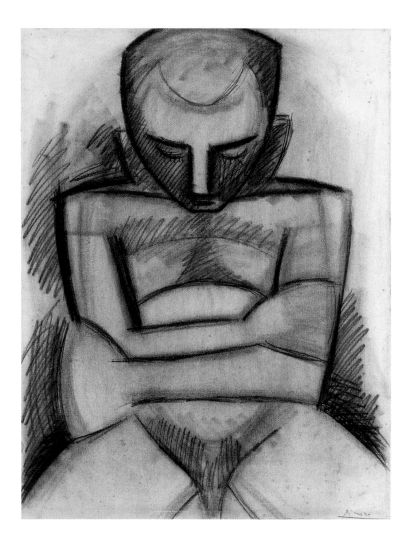 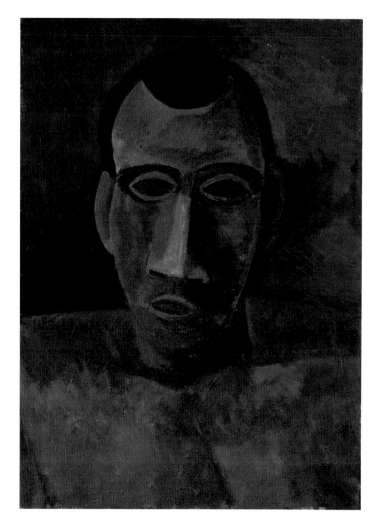

Pablo Picasso. Spanish, 1881–1973

Seated Nude 1908
Charcoal and graphite on paper
24 7/8 x 18 7/8 in. (63.2 x 47.9 cm)

Bequest of Scofield Thayer, 1982
1984.433.278

Bust of a Man 1908
Oil on canvas
24 1/2 x 17 1/8 in. (62.2 x 43.5 cm)

Bequest of Florene M. Schoenborn, 1995
1996.403.5

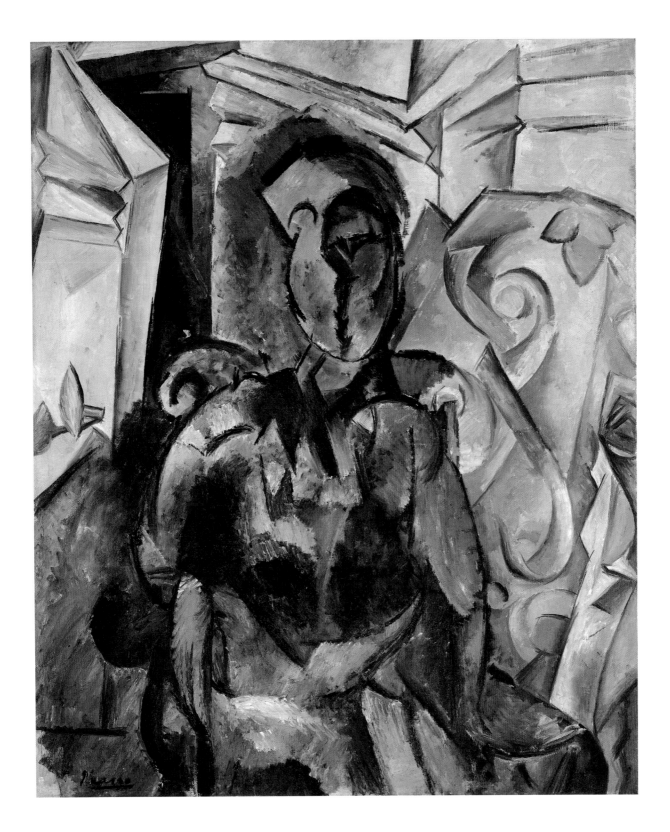

Nude in an Armchair Winter 1909–10
Oil on canvas
32 x 25 3/4 in. (81.3 x 65.4 cm)

The Mr. and Mrs. Klaus G. Perls Collection, 1997
1997.149.7

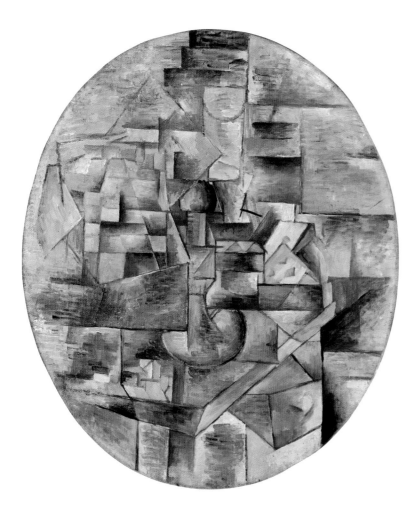

Georges Braque. French, 1882–1963

Candlestick and Playing Cards Winter 1909–10
Oil on canvas
Oval: 25 5/8 x 21 3/8 in. (65.1 x 54.3 cm)

The Mr. and Mrs. Klaus G. Perls Collection, 1997
1997.149.12

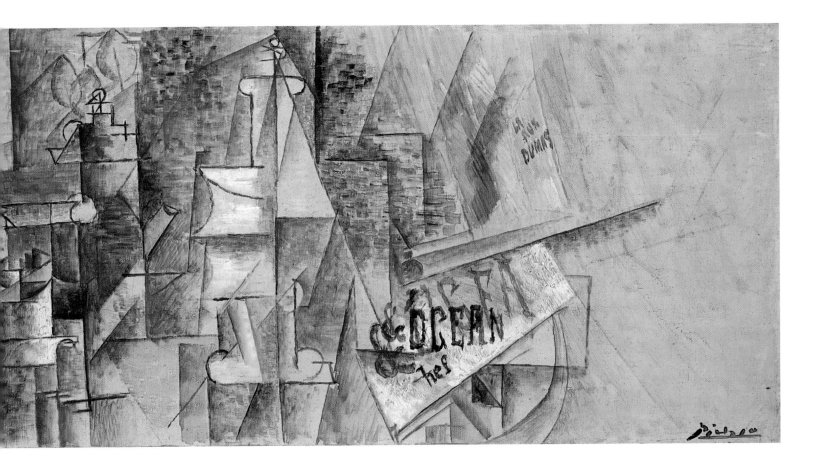

Pablo Picasso. Spanish, 1881–1973

Still Life with a Pipe Rack 1911
Oil on canvas
20 x 50 3/8 in. (50.8 x 128 cm)

The Mr. and Mrs. Klaus G. Perls Collection, 1997
1997.149.6

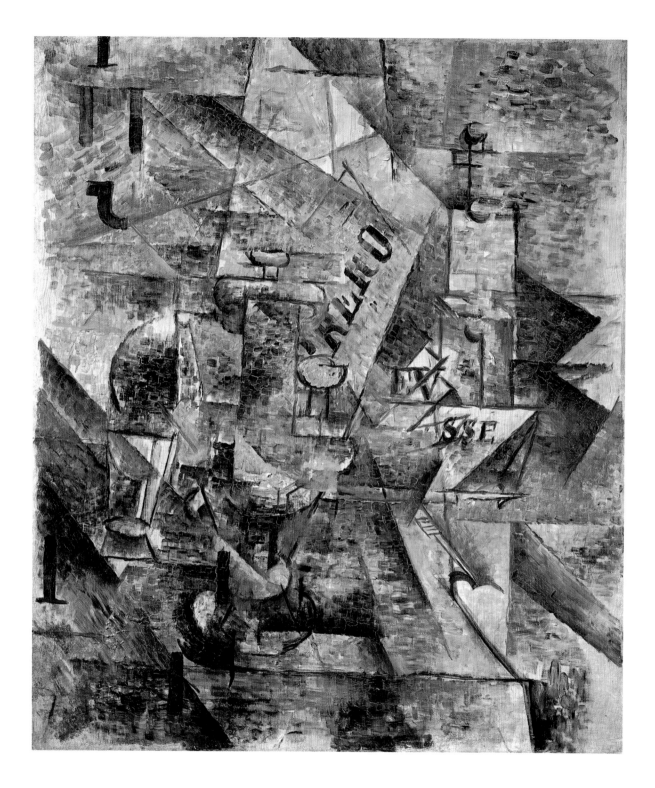

Georges Braque. French, 1882–1963

Still Life with a Pair of Banderillas 1911
Oil on canvas
25 3/4 x 21 5/8 in. (65.5 x 55 cm)

Jacques and Natasha Gelman Collection, 1998
1999.363.11

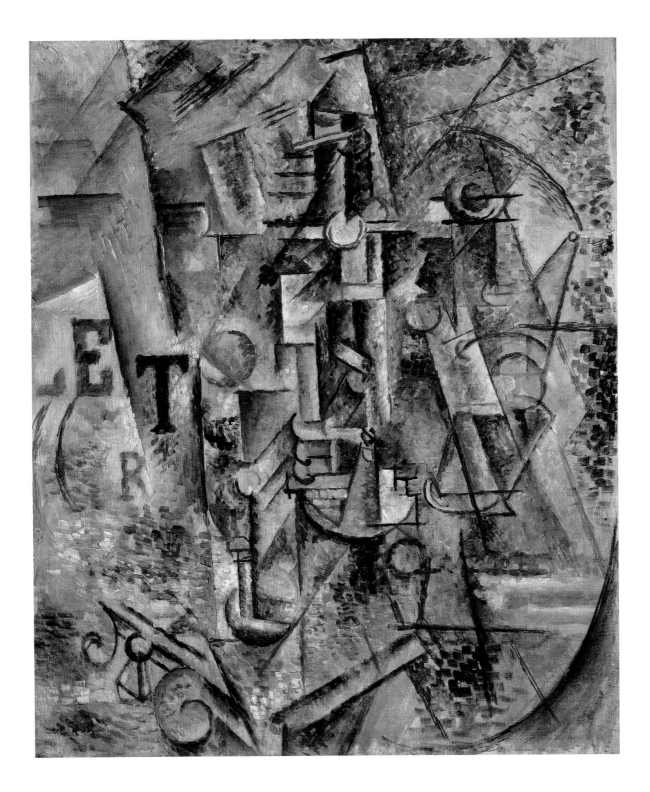

Pablo Picasso. Spanish, 1881–1973

Still Life with a Bottle of Rum 1911
Oil on canvas
24 1/8 x 19 7/8 in. (61.3 x 50.5 cm)

Jacques and Natasha Gelman Collection, 1998
1999.363.63

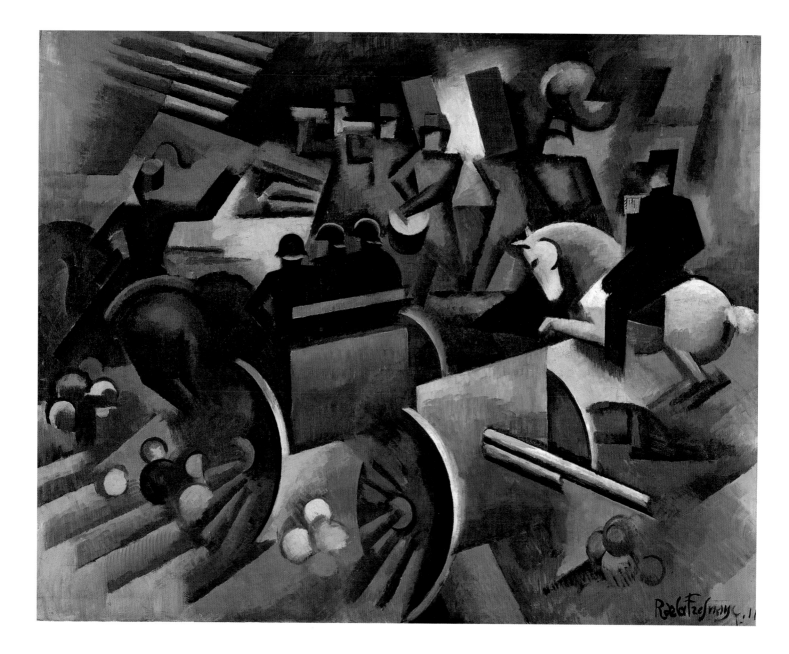

Roger de La Fresnaye. French, 1885–1925

Artillery 1911
Oil on canvas
51 1/4 x 62 3/4 in. (130.2 x 159.4 cm)

Gift of Florene M. Schoenborn, 1991
1991.397

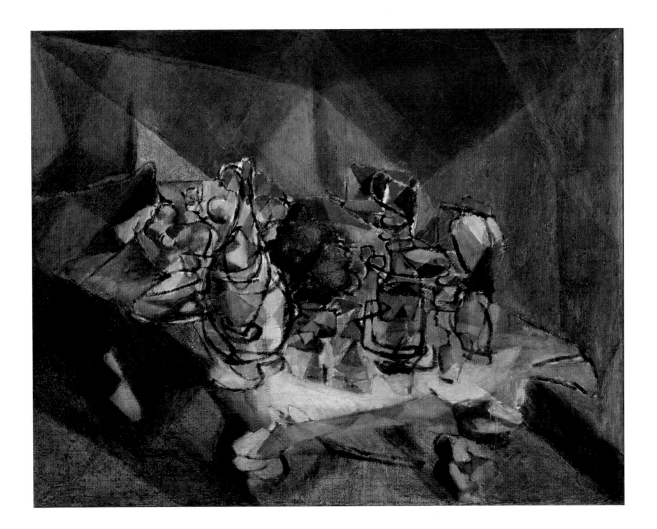

Jacques Villon. French, 1875–1963

The Dining Table 1912
Oil on canvas
25 3/4 x 32 in. (65.4 x 81.3 cm)

Purchase, Gift of Mr. and Mrs. Justin K. Thannhauser, by exchange, 1983
1983.169.1

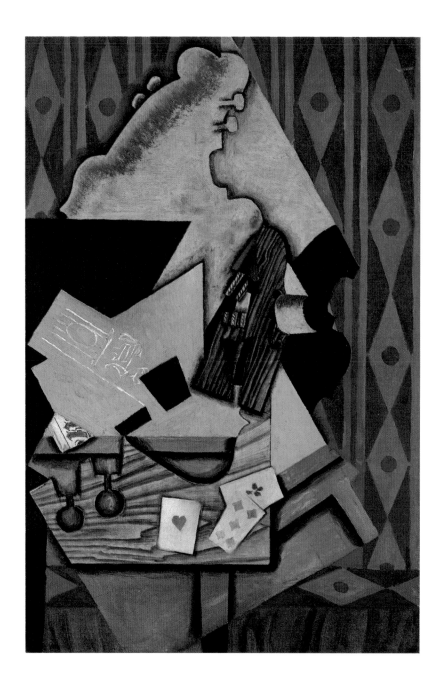

Juan Gris. Spanish, 1887–1927

Violin and Playing Cards 1913
Oil on canvas
39 3/8 x 25 3/4 in. (100 x 65.4 cm)

Bequest of Florene M. Schoenborn, 1995
1996.403.14

Pablo Picasso. Spanish, 1881–1973

Guitar and Clarinet on a Mantelpiece 1915
Oil on canvas
51 1/4 x 38 1/4 in. (130.2 x 97.2 cm)

Bequest of Florene M. Schoenborn, 1995
1996.403.3

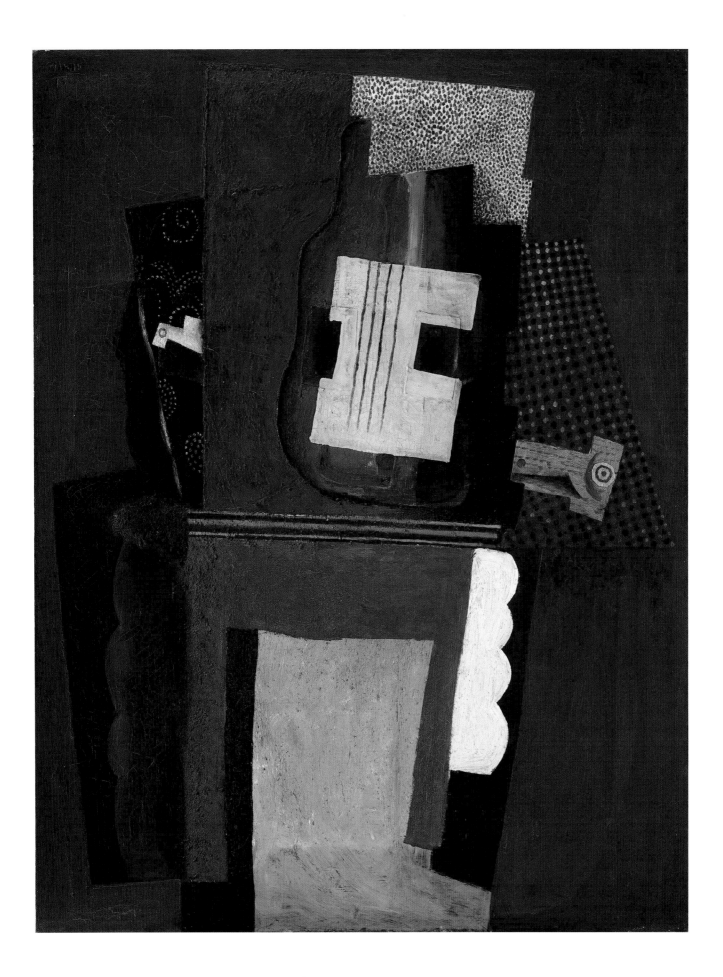

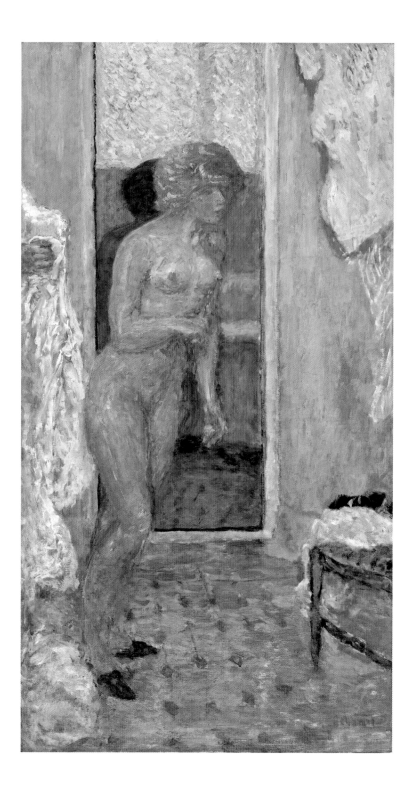

Pierre Bonnard. French, 1867–1947

After the Morning Bath 1910
Oil on canvas
48 1/4 x 25 1/2 in. (122.5 x 65 cm)

Jacques and Natasha Gelman Collection, 1998
1999.363.5

Henri Matisse. French, 1869–1954

Nasturtiums with the Painting "Dance II" 1912
Oil on canvas
75 1/2 x 45 3/8 in. (191.8 x 115.3 cm)

Bequest of Scofield Thayer, 1982
1984.433.16

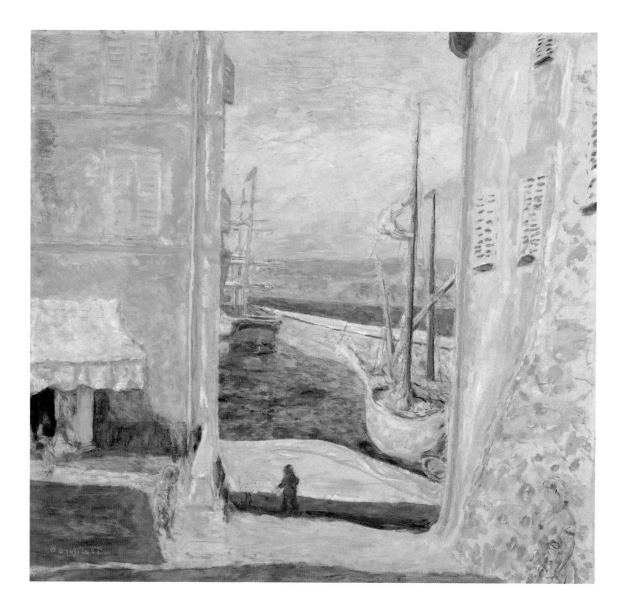

Pierre Bonnard. French, 1867–1947

View of the Old Port, Saint Tropez 1911
Oil on canvas
33 x 34 in. (83.8 x 86.4 cm)

Bequest of Scofield Thayer, 1982
1984.433.1

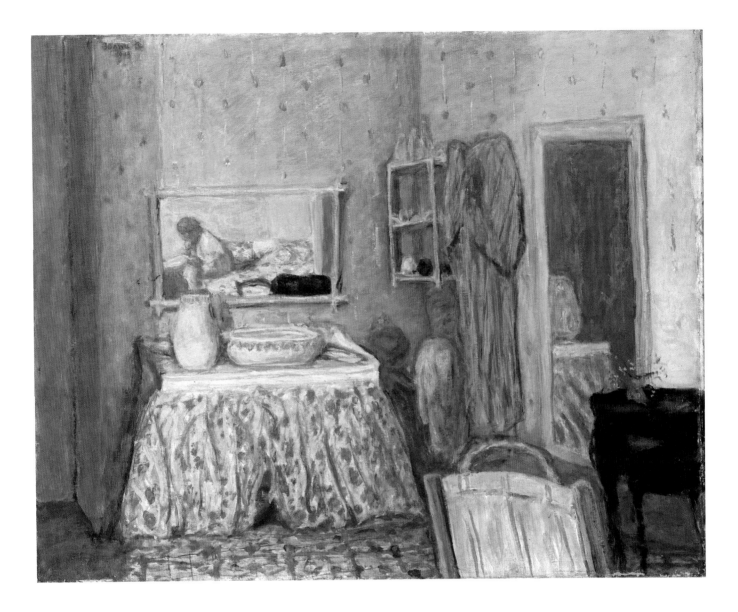

The Dressing Room 1914
Oil on canvas
28 3/8 x 34 3/4 in. (72.1 x 88.3 cm)

Bequest of Scofield Thayer, 1982
1984.433.3

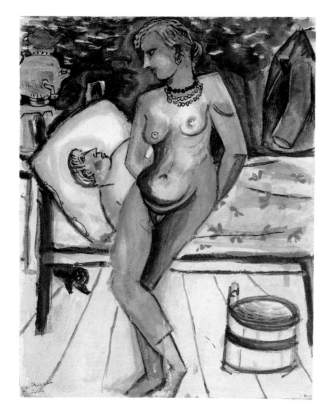

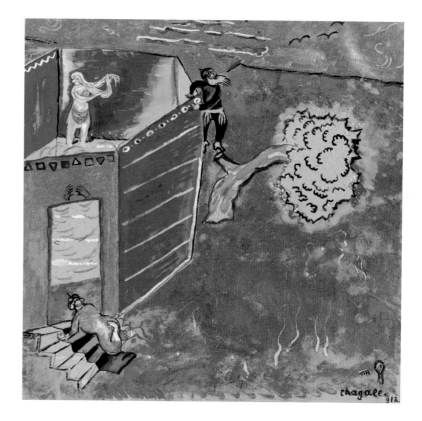

Marc Chagall. French, born Russia, 1887–1985

Joseph and Potiphar's Wife 1911
Watercolor and gouache on paper
12 1/4 x 9 1/2 in. (31.1 x 24.1 cm)

Bequest of Scofield Thayer, 1982
1984.433.60

Susanna and the Elders 1912
Gouache, metallic paints, pen and ink on paper
6 7/8 x 6 3/4 in. (17.5 x 17.1 cm)

Bequest of Scofield Thayer, 1982
1984.433.57

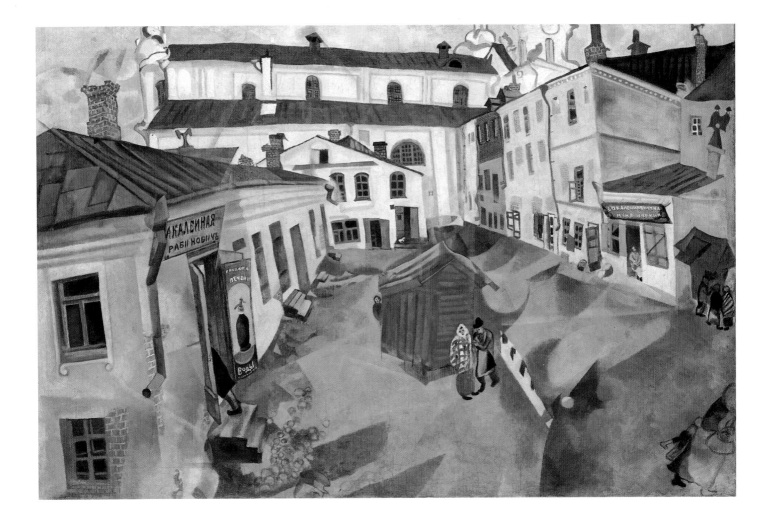

The Marketplace, Vitebsk 1917
Oil on canvas
26 1/8 x 38 1/4 in. (66.4 x 97.2 cm)

Bequest of Scofield Thayer, 1982
1984.433.6

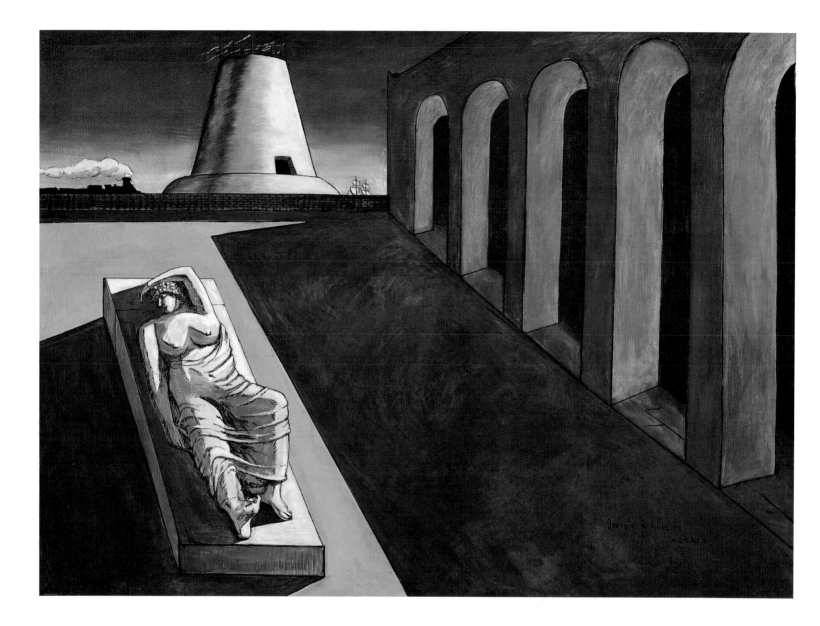

Giorgio de Chirico. Italian, 1888–1978

Ariadne 1913
Oil and graphite on canvas
53 3/8 x 71 in. (135.6 x 180 cm)

Bequest of Florene M. Schoenborn, 1995
1996.403.10

The Jewish Angel 1916
Oil on canvas
26 5/8 x 17 1/4 in. (67.5 x 44 cm)

Jacques and Natasha Gelman Collection, 1998
1999.363.15

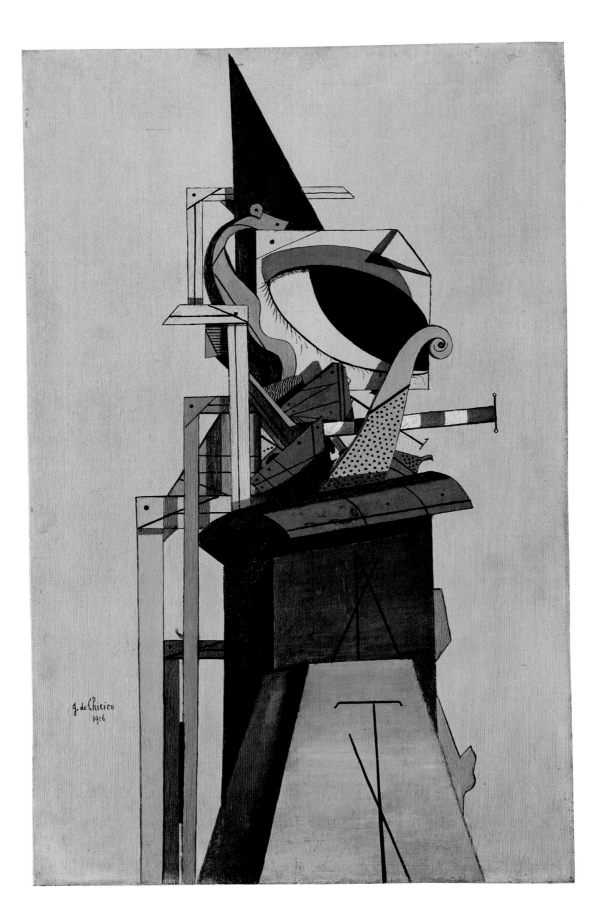

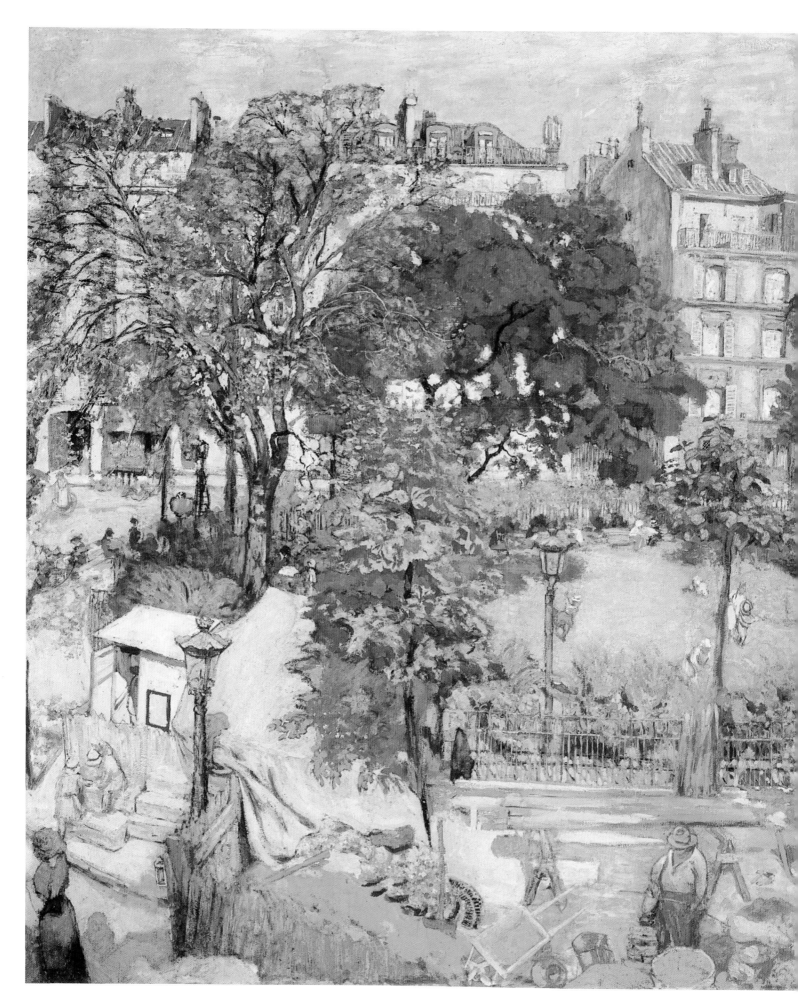

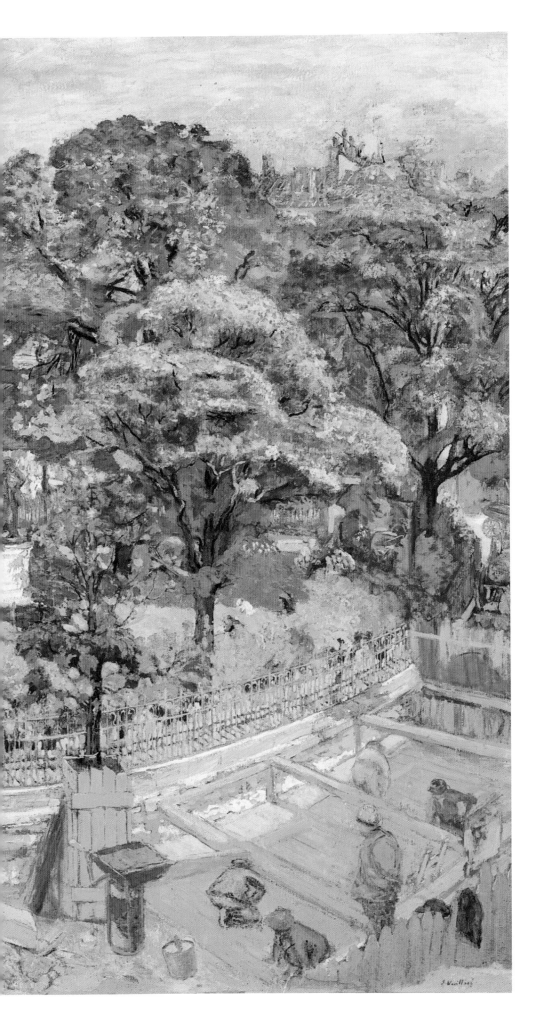

Edouard Vuillard. French, 1868–1940

Place Vintimille, Paris 1916
Distemper on canvas
64 x 90 in. (162.6 x 228.6 cm)

Promised Gift of an Anonymous Donor

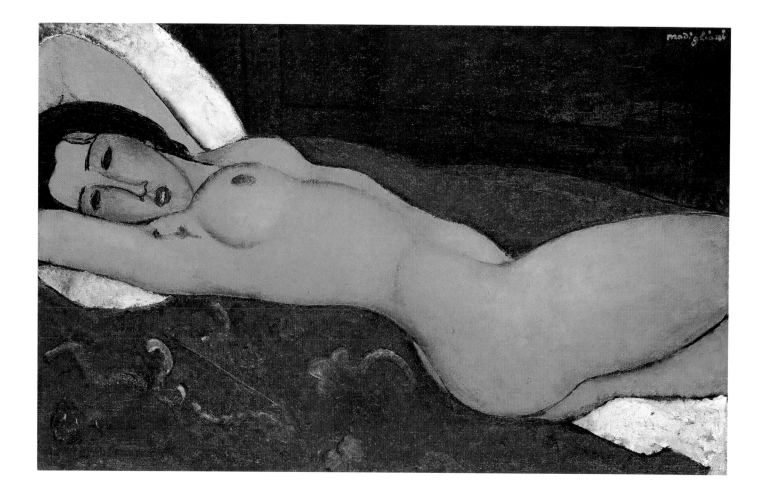

Amedeo Modigliani. Italian, 1884–1920

Reclining Nude 1917
Oil on canvas
23 7/8 x 36 1/2 in. (60.6 x 92.7 cm)

The Mr. and Mrs. Klaus G. Perls Collection, 1997
1997.149.9

Flower Vendor 1919
Oil on canvas
45 7/8 x 28 7/8 in. (116.5 x 73.3 cm)

Bequest of Florene M. Schoenborn, 1995
1996.403.9

Pierre Bonnard. French, 1867–1947

Morning in the Garden at Vernonnet 1917
Oil on canvas
33 3/4 x 44 3/4 in. (85.7 x 113.7 cm)

Bequest of Scofield Thayer, 1982
1984.433.4

88

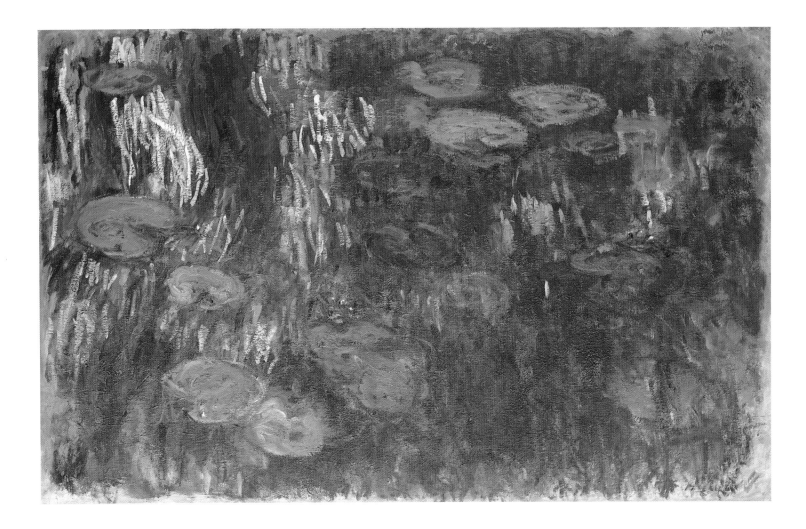

Claude Monet. French, 1840–1926

Reflections, the Water Lily Pond at Giverny ca. 1920
Oil on canvas
51 1/4 x 79 in. (130.2 x 200.7 cm)

Gift of Louise Reinhardt Smith, 1983
1983.532

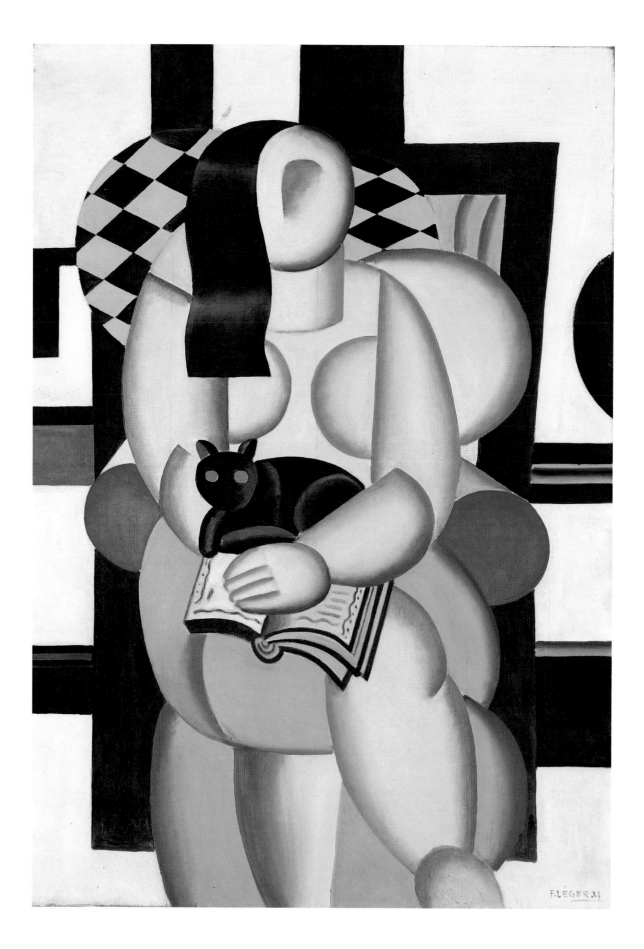

Fernand Léger. French, 1881–1955

Woman with a Cat 1921
Oil on canvas
51 3/8 x 35 1/4 in. (130.5 x 89.5 cm)

Gift of Florene M. Schoenborn, 1994
1994.486

Three Women by a Garden 1922
Oil on canvas
25 1/2 x 36 in. (64.8 x 91.4 cm)

Bequest of Mr. and Mrs. Allan D. Emil, in honor of
William S. Lieberman, 1987
1987.125.1

Henri Matisse. French, 1869–1954

Girl by a Window 1921
Oil on canvas
18 3/8 x 21 7/8 in. (46.7 x 55.6 cm)

Gift of Alice Albright Arlen, in honor of her mother, Josephine Patterson Albright, 1994
1994.545

92

The Goldfish Bowl Winter 1921–22
Oil on canvas
21 3/8 x 25 3/4 in. (54.3 x 65.4 cm)

Bequest of Scofield Thayer, 1982
1984.433.19

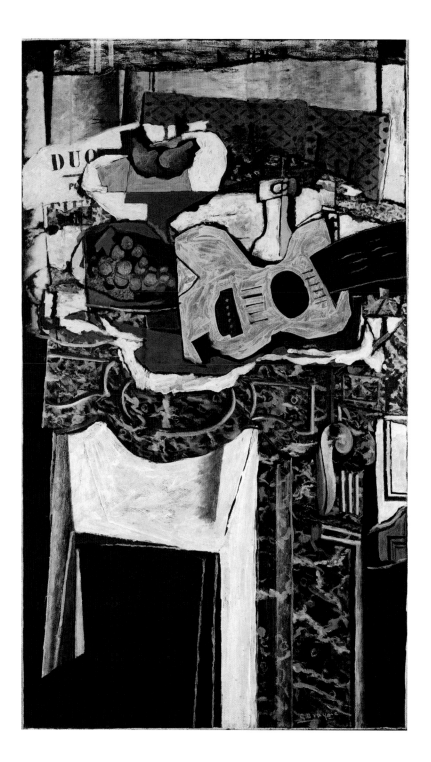

Georges Braque. French, 1882–1963

Guitar and Still Life on a Mantelpiece 1921
Oil with sand on canvas
51 3/8 x 29 3/8 in. (130.5 x 74.6 cm)

Bequest of Florene M. Schoenborn, 1995
1996.403.11

Guitar and Still Life on a Guéridon 1922
Oil with sand on canvas
75 x 27 3/4 in. (190.5 x 70.5 cm)

Gift of Louise Reinhardt Smith, in honor of
William S. Lieberman, 1979
1979.481

94

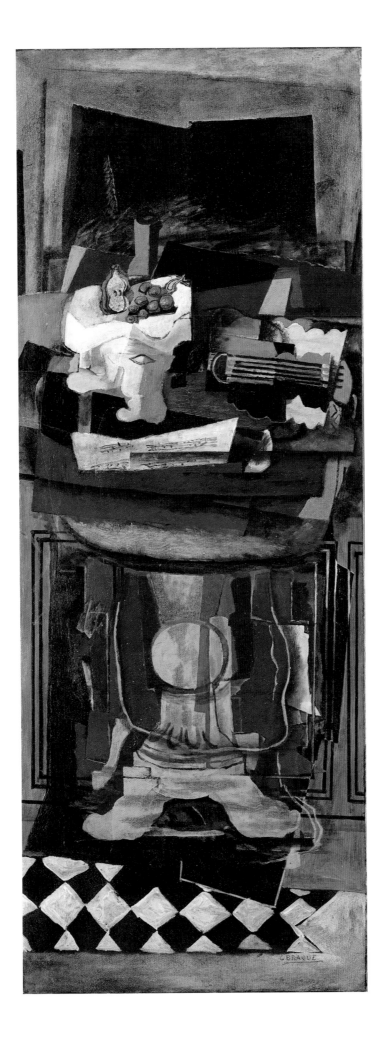

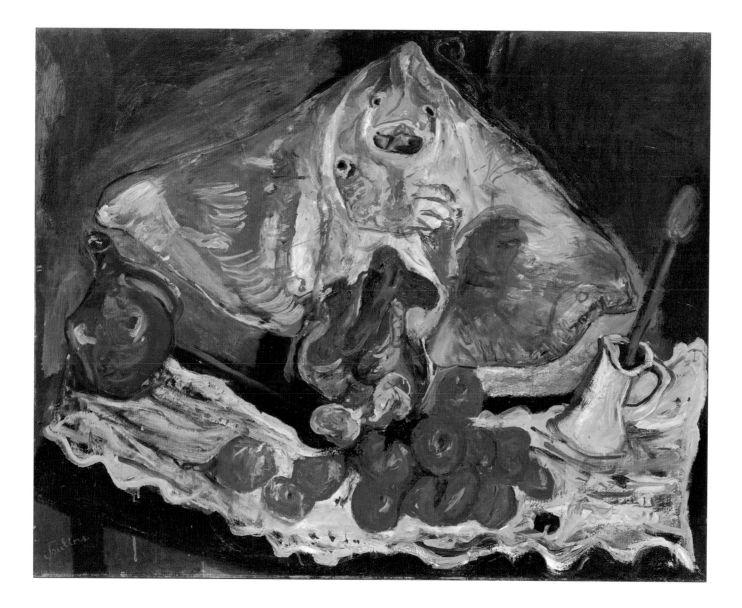

Chaim Soutine. French, born Lithuania, 1893–1943

The Ray ca. 1924
Oil on canvas
32 x 39 3/8 in. (81.3 x 100 cm)

The Mr. and Mrs. Klaus G. Perls Collection, 1997
1997.149.1

96

View of Cagnes ca. 1924–25
Oil on canvas
23 3/4 x 28 3/4 in. (60.3 x 73 cm)

The Mr. and Mrs. Klaus G. Perls Collection, 1997
1997.149.2

Max Ernst. French, born Germany, 1891–1976

Gala Eluard 1924
Oil on canvas
31 7/8 x 25 5/8 in. (81 x 65.1 cm)

Promised Gift of Muriel Kallis Newman,
The MURIEL KALLIS STEINBERG NEWMAN Collection

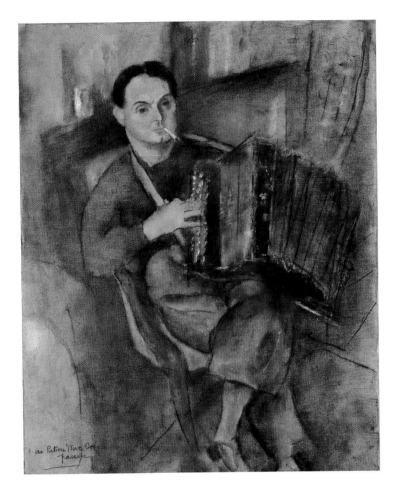

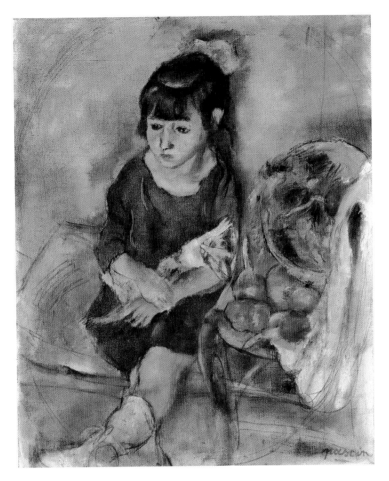

Jules Pascin. American, born Bulgaria, 1885–1930

Pierre Mac Orlan 1924
Oil on canvas
36 1/4 x 28 3/4 in. (92.1 x 73 cm)

The Mr. and Mrs. Klaus G. Perls Collection, 1997
1997.149.8

Girl with a Kitten ca. 1926
Oil and charcoal on canvas
31 5/8 x 25 1/4 in. (80.3 x 64.1 cm)

Gift of Leonore S. Gershwin 1987 Trust, 1993
1993.89.2

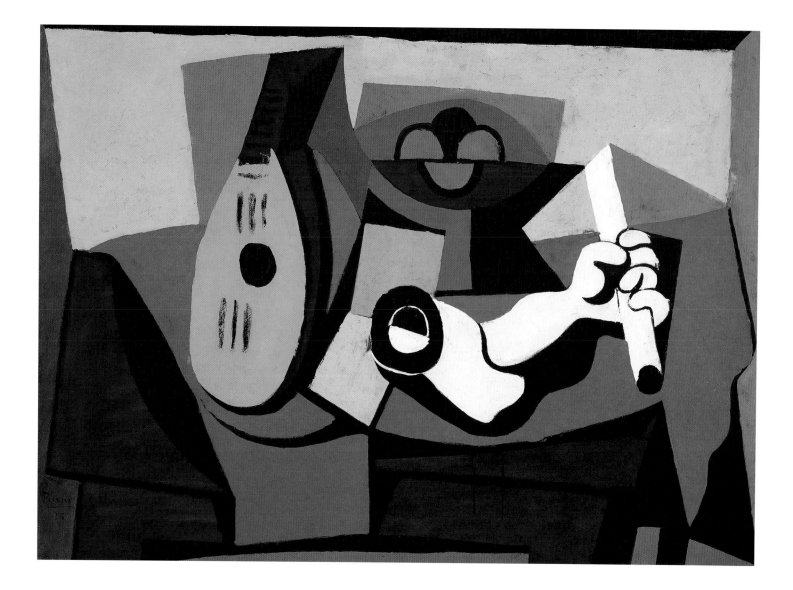

Pablo Picasso. Spanish, 1881–1973

Mandolin, Fruit Bowl, and Plaster Arm 1925
Oil on canvas
38 1/2 x 51 1/4 in. (97.8 x 130.2 cm)

Bequest of Florene M. Schoenborn, 1995
1996.403.2

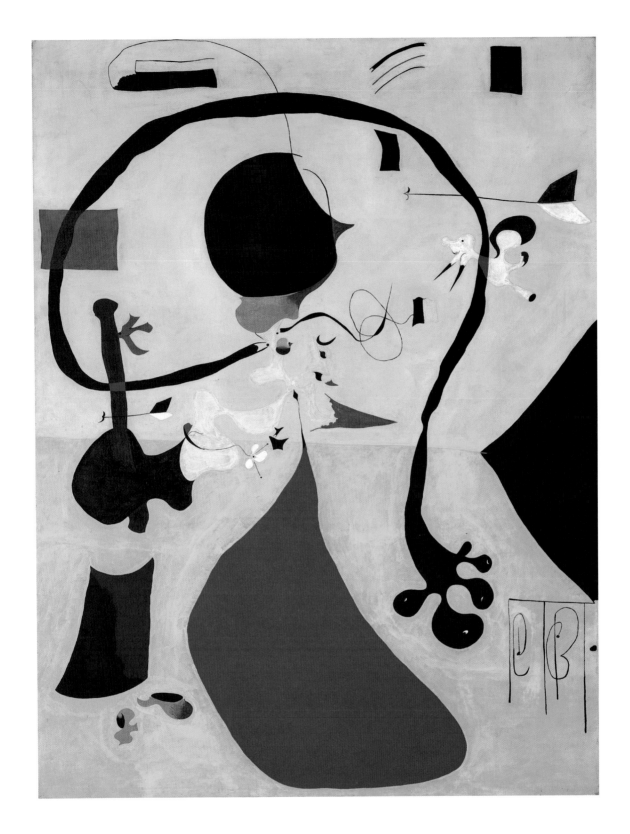

Joan Miró. Spanish, 1893–1983

Dutch Interior 1928
Oil on canvas
51 1/8 x 38 1/8 in. (129.9 x 96.8 cm)

Bequest of Florene M. Schoenborn, 1995
1996.403.8

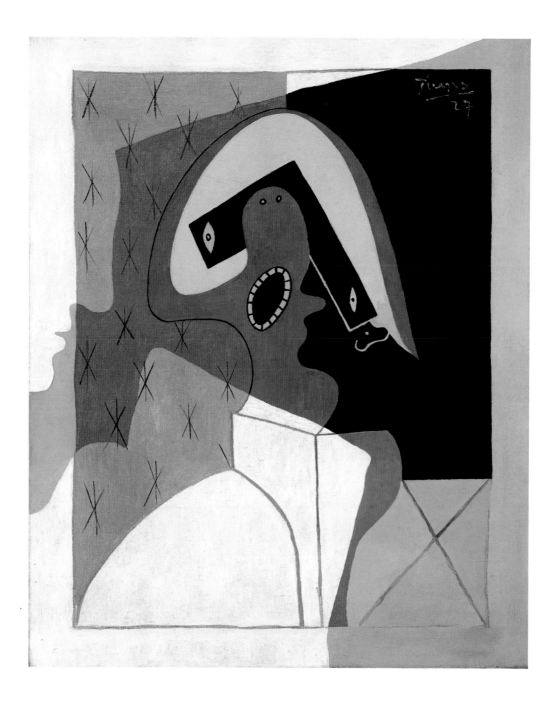

Pablo Picasso. Spanish, 1881–1973

Harlequin 1927
Oil on canvas
32 x 25 5/8 in. (81.3 x 65.1 cm)

The Mr. and Mrs. Klaus G. Perls Collection, 1997
1997.149.5

Nude Standing by the Sea 1929
Oil on canvas
51 1/8 x 38 1/8 in. (129.9 x 96.8 cm)

Bequest of Florene M. Schoenborn, 1995
1996.403.4

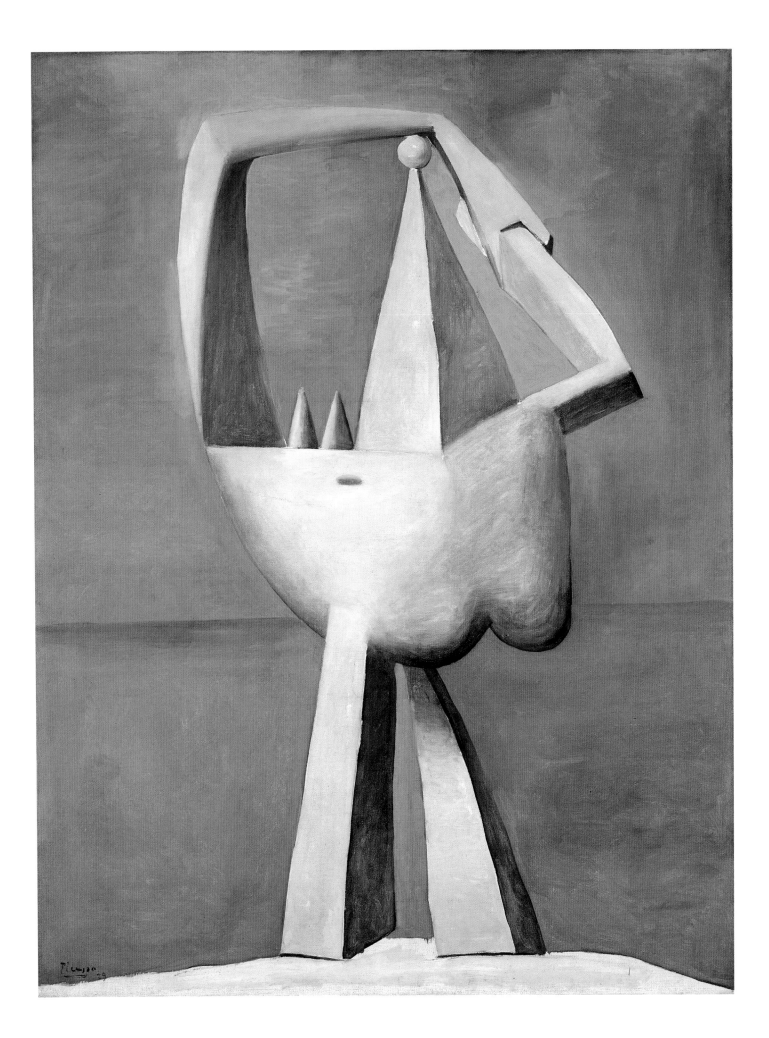

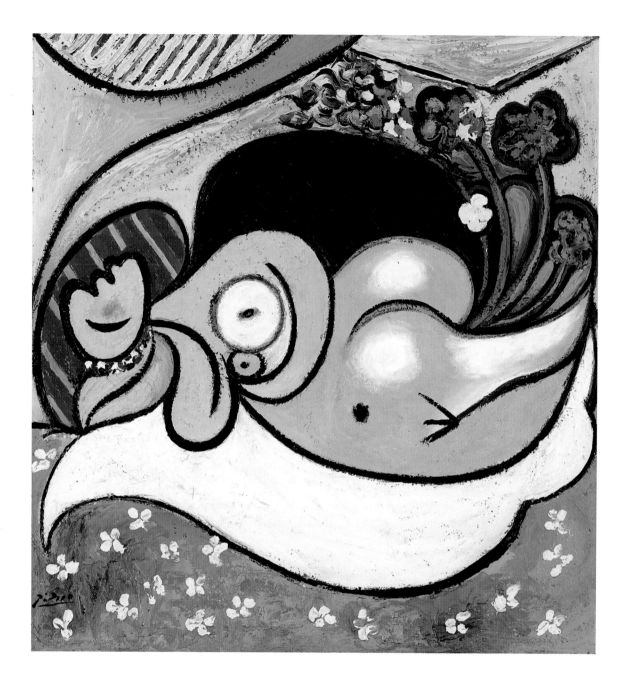

Pablo Picasso. Spanish, 1881–1973

The Dreamer July 1932
Oil on canvas
39 7/8 x 36 3/4 in. (101.3 x 93.3 cm)

The Mr. and Mrs. Klaus G. Perls Collection, 1997
1997.149.4

Girl Reading at a Table 1934
Oil and enamel on canvas
63 7/8 x 51 3/8 in. (162.2 x 130.5 cm)

Bequest of Florene M. Schoenborn, in honor of
William S. Lieberman, 1995
1996.403.1

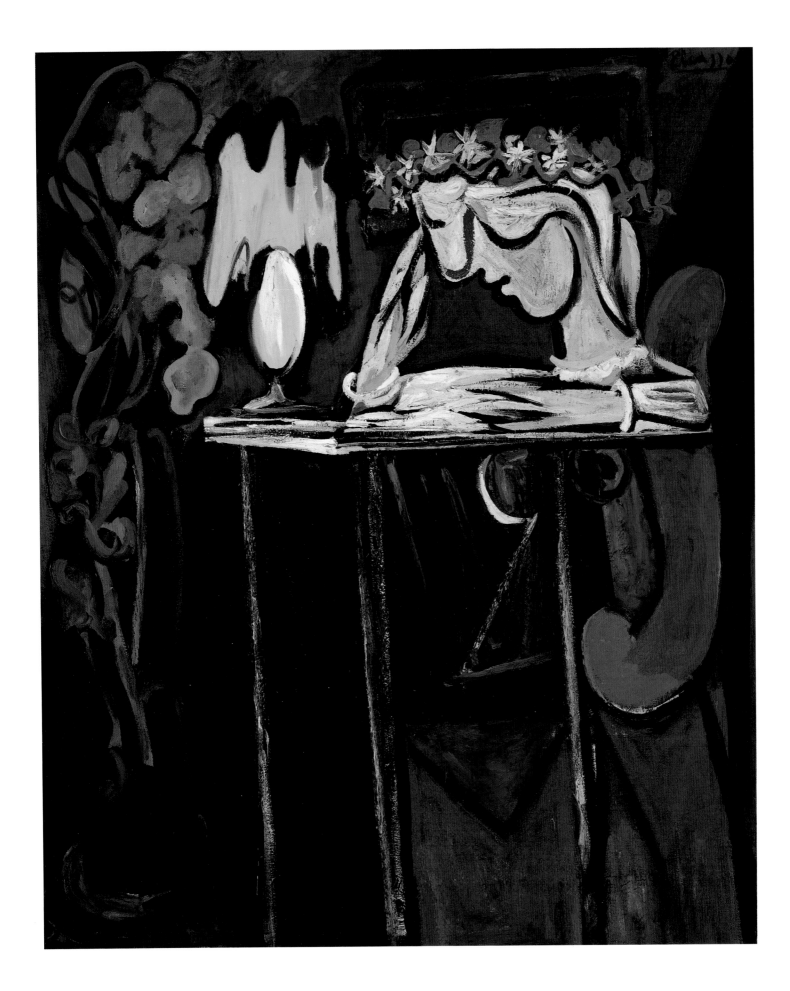

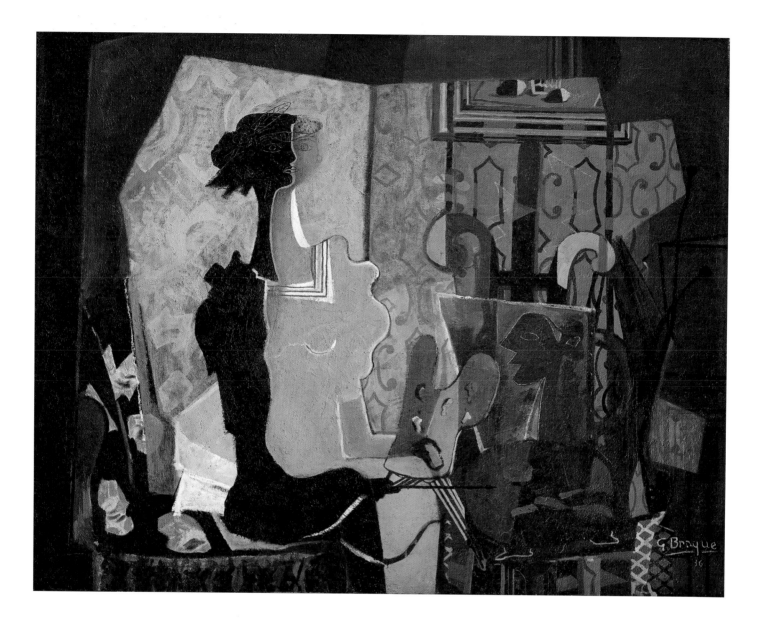

Georges Braque. French, 1882–1963

Woman Seated at an Easel 1936
Oil with sand on canvas
51 1/2 x 63 7/8 in. (130.8 x 162.2 cm)

Bequest of Florene M. Schoenborn, 1995
1996.403.12

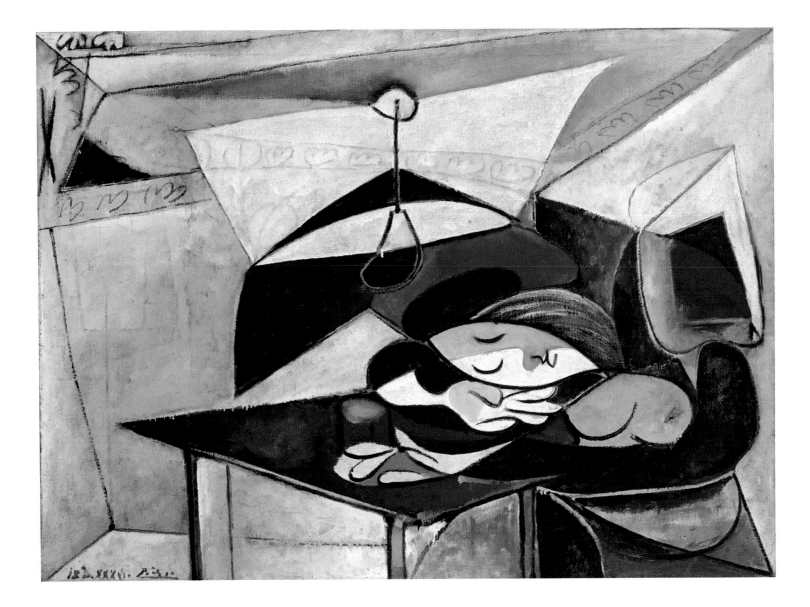

Pablo Picasso. Spanish, 1881–1973

Girl Sleeping at a Table December 18, 1936
Oil on canvas
38 1/4 x 51 1/4 in. (97.2 x 130.2 cm)

The Mr. and Mrs. Klaus G. Perls Collection, 1997
1997.149.3

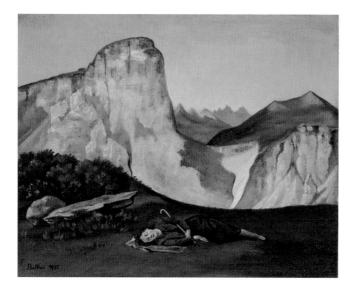

Balthus (Balthasar Klossowski). French, born 1908

Summertime 1935
Oil on canvas
23 5/8 x 28 3/4 in. (60 x 73 cm)

Purchase, Gift of Himan Brown, by exchange, 1996
1996.176

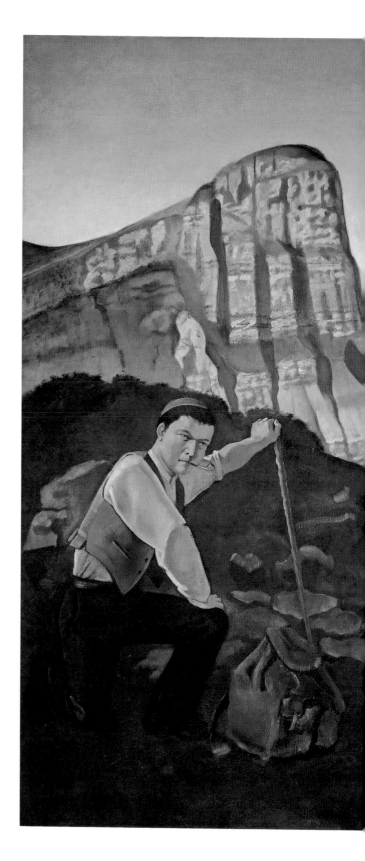

The Mountain 1937
Oil on canvas
98 x 144 in. (248.9 x 365.8 cm)

Purchase, Gifts of Mr. and Mrs. Nate B. Spingold and Nathan
Cummings, Rogers Fund and The Alfred N. Punnett Endowment
Fund, by exchange, and Harris Brisbane Dick Fund, 1982
1982.530

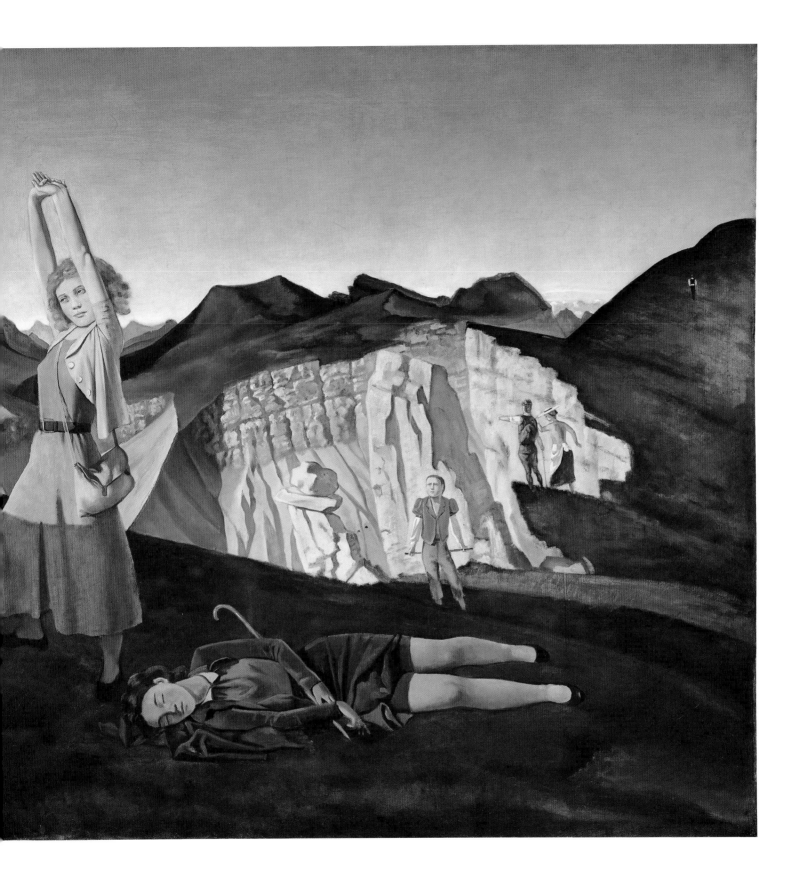

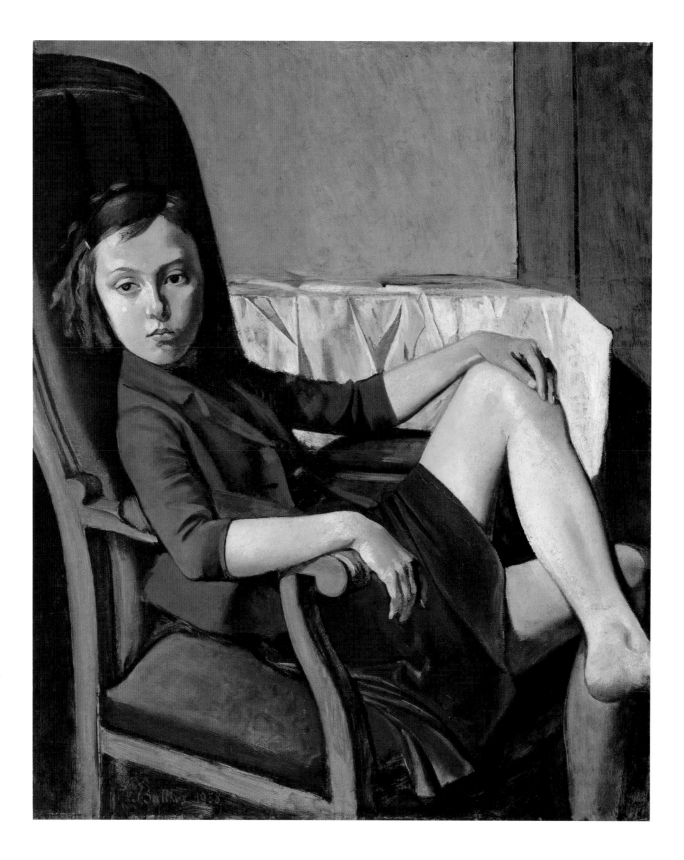

Balthus (Balthasar Klossowski). French, born 1908

Thérèse 1938
Oil on cardboard mounted on wood
39 1/2 x 32 in. (100.3 x 81.3 cm)

Bequest of Mr. and Mrs. Allan D. Emil, in honor of
William S. Lieberman, 1987
1987.125.2

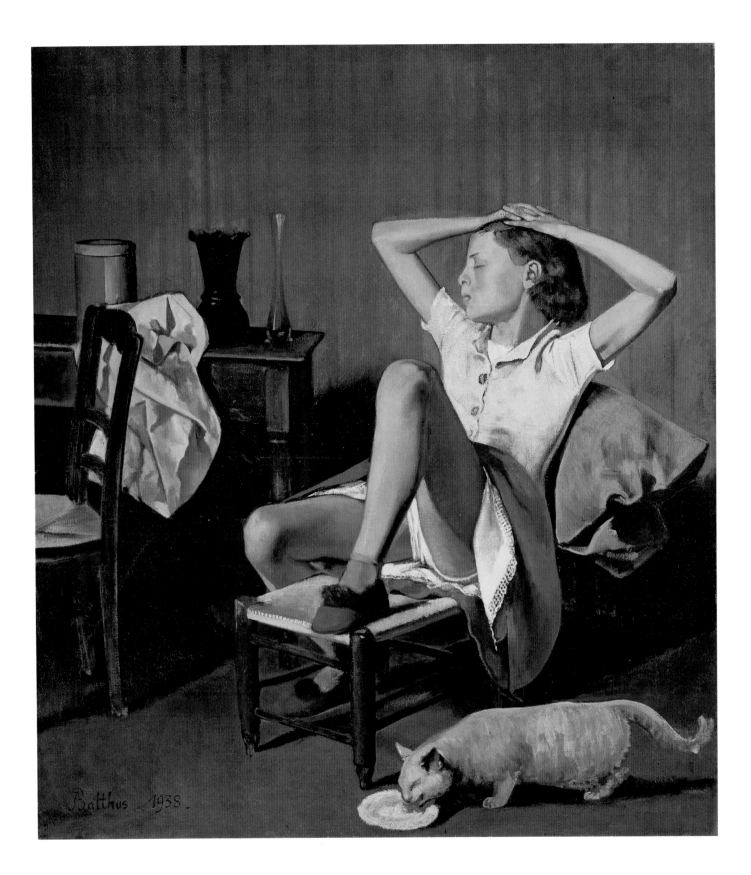

Thérèse Dreaming 1938
Oil on canvas
59 x 51 in. (150 x 130 cm)

Jacques and Natasha Gelman Collection, 1998
1999.363.2

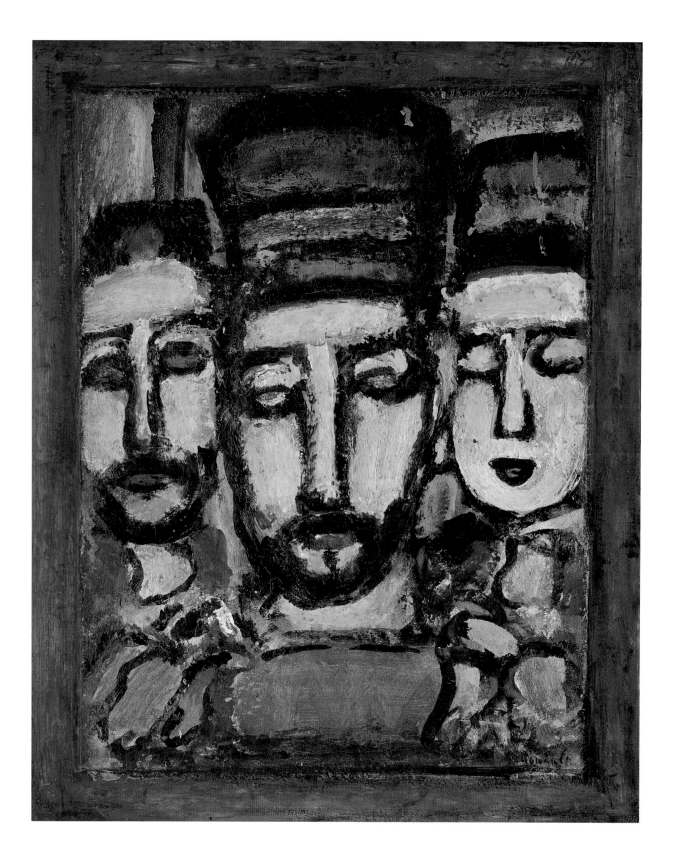

Georges Rouault. French, 1871–1958

Three Judges ca. 1938
Oil on canvas
27 1/4 x 21 1/2 in. (69.2 x 54.6 cm)

The Frederick and Helen Serger Collection, Bequest of Helen Serger,
in honor of William S. Lieberman, 1989
1990.274.3

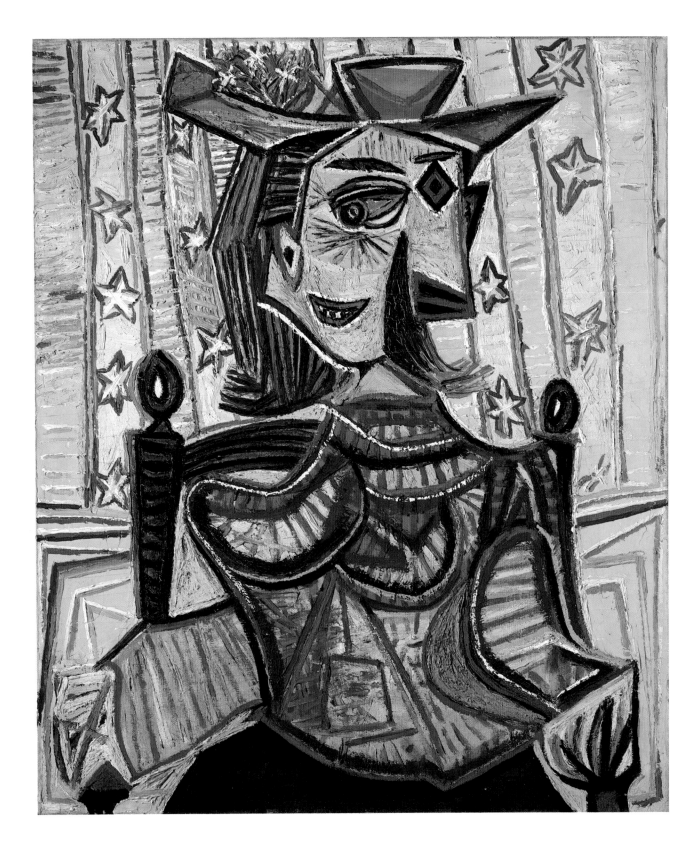

Pablo Picasso. Spanish, 1881–1973

Dora Maar in an Armchair October 26, 1939
Oil on canvas
28 7/8 x 23 3/4 in. (73.3 x 60.3 cm)

The Mr. and Mrs. Klaus G. Perls Collection, 1998
1998.23

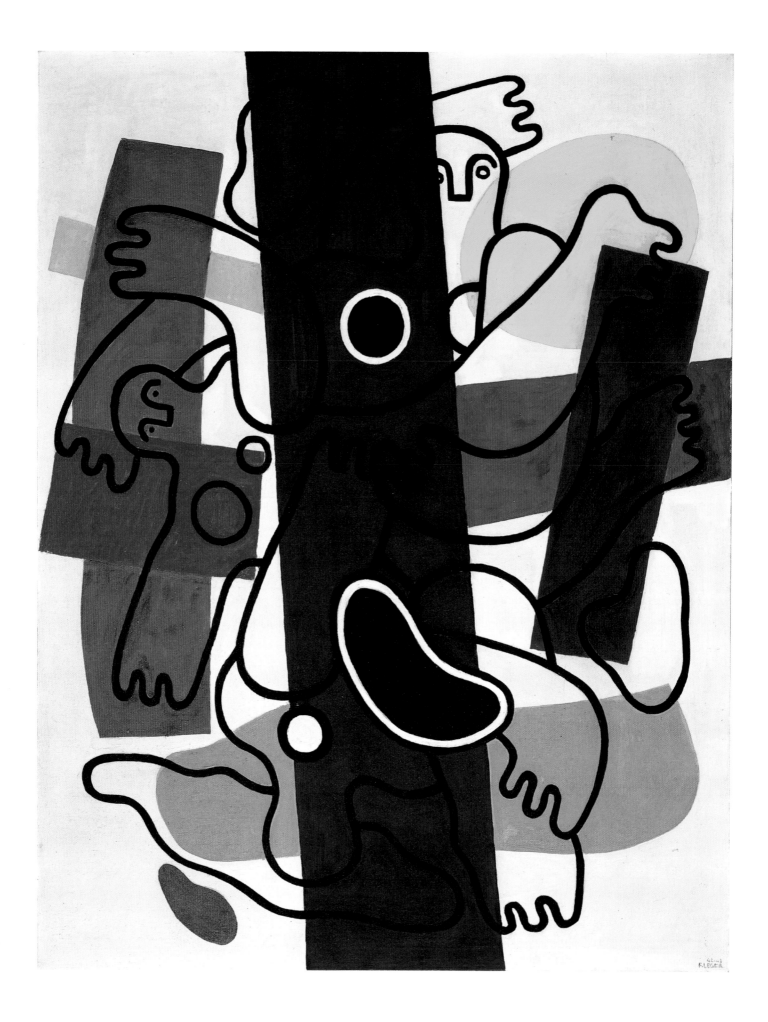

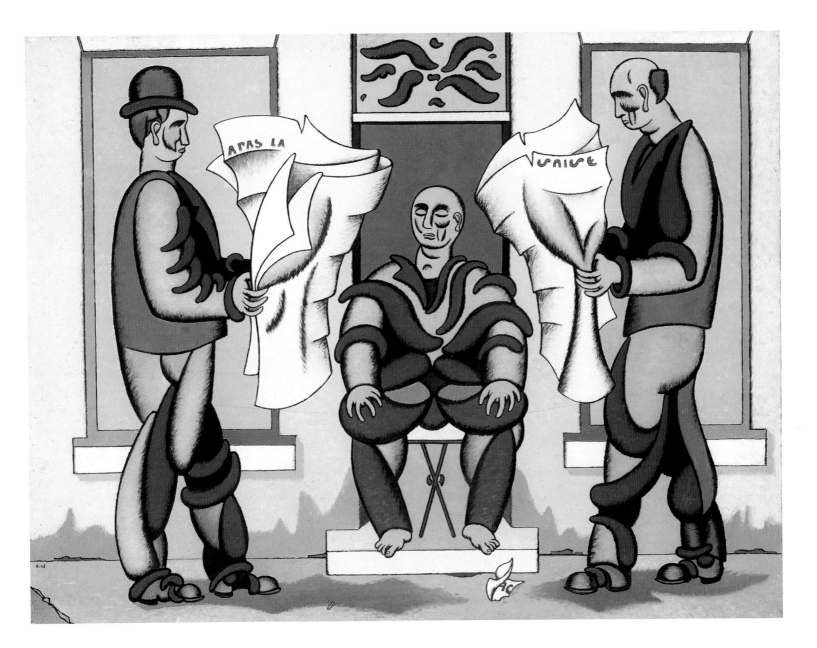

Fernand Léger. French, 1881–1955

Divers (Blue and Black) 1942–43
Oil on canvas
66 1/4 x 50 1/4 in. (168.2 x 127.5 cm)

Jacques and Natasha Gelman Collection, 1998
1999.363.37

Jean Hélion. French, 1904–1987

Newspaper Readers 1948
Oil on canvas
58 x 45 in. (147.3 x 114.3 cm)

Gift of The Joseph Cantor Foundation, 1982
1982.148.2

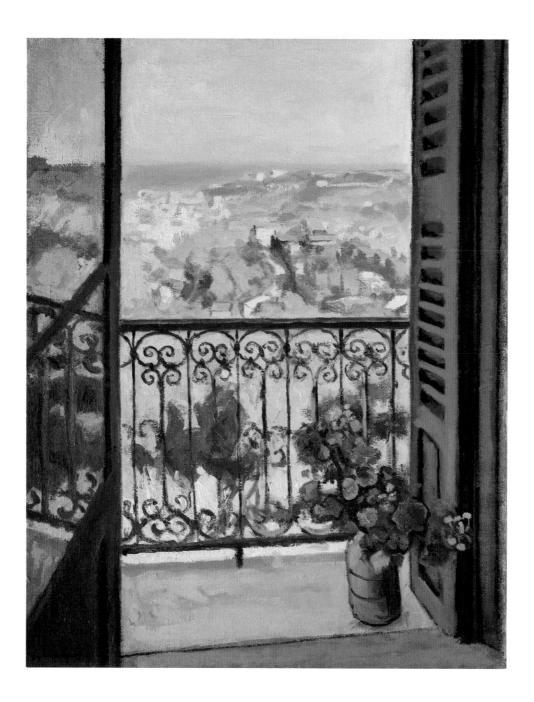

Albert Marquet. French, 1875–1947

View from a Balcony 1945
Oil on canvas
25 5/8 x 19 3/4 in. (65.1 x 50.2 cm)

Partial and Promised Gift of Mr. and Mrs. Douglas Dillon, 1998
1998.412.2

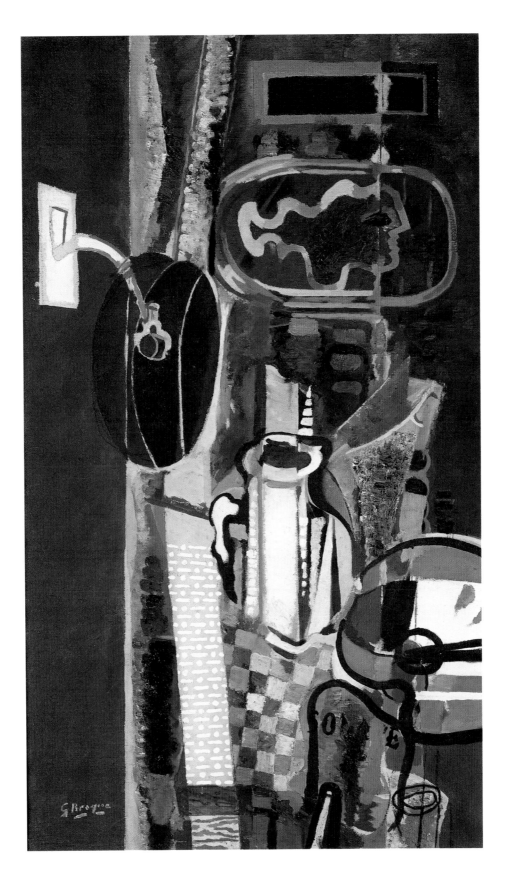

Georges Braque. French, 1882–1963

The Studio 1949
Oil on canvas
51 1/2 x 29 1/8 in. (130.8 x 74 cm)

Bequest of Florene M. Schoenborn, 1995
1996.403.13

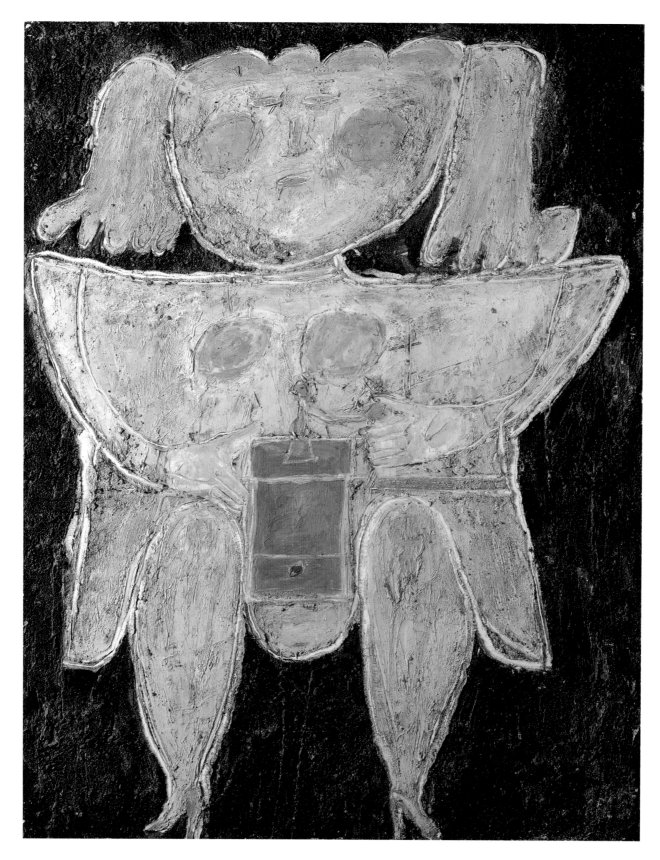

Jean Dubuffet. French, 1901–1985

Woman Grinding Coffee Christmas 1945
Plaster, oil, and tar with sand on canvas
45 3/4 x 35 in. (116.2 x 88.9 cm)

In honor of Ralph F. Colin,
Gift of his wife Georgia Talmey Colin, 1995
1995.142

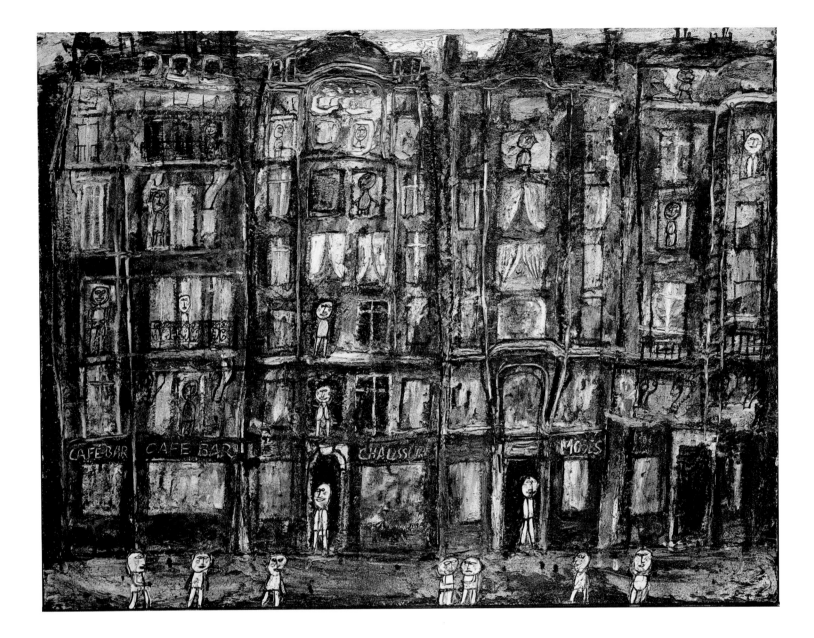

Apartment Houses, Paris 1946
Oil with sand and charcoal on canvas
44 7/8 x 57 3/8 in. (114 x 145.7 cm)

Bequest of Florene M. Schoenborn, 1995
1996.403.15

CHECKLIST

The checklist combines Acquisitions 1947–1978 and Acquisitions 1979–1999 and is alphabetically arranged by artist's name. The paintings are listed chronologically. Dates not inscribed on a painting appear in parentheses, and in the dimensions height precedes width. References to definitive catalogues are cited in abbreviated form. For complete citations see Catalogues Raisonnés.

Balthus (Balthasar Klossowski)
French, born 1908

Summertime 1935
Oil on canvas
23 5/8 x 28 3/4 in. (60 x 73 cm)

Purchase, Gift of Himan Brown, by exchange, 1996
1996.176

Page 108

The Mountain (1937)
Oil on canvas
98 x 144 in. (248.9 x 365.8 cm)

Purchase, Gifts of Mr. and Mrs. Nate B. Spingold and Nathan Cummings, Rogers Fund and The Alfred N. Punnett Endowment Fund, by exchange, and Harris Brisbane Dick Fund, 1982
1982.530

Pages 108–109

Thérèse 1938
Oil on cardboard mounted on wood
39 1/2 x 32 in. (100.3 x 81.3 cm)

Bequest of Mr. and Mrs. Allan D. Emil, in honor of William S. Lieberman, 1987
1987.125.2

Page 110

Thérèse Dreaming 1938
Oil on canvas
59 x 51 in. (150 x 130 cm)

Jacques and Natasha Gelman Collection, 1998
1999.363.2

Page 111

Pierre Bonnard
French, 1867–1947

The Children's Meal (1895)
Oil on canvas
23 3/8 x 29 3/8 in. (59.4 x 74.6 cm)

Gift of David Allen Devrishian, 1999
1999.180.1
Dauberville, II, no. 105 as "Grandmother, Mother and Two Grand-Children," 1895

Page 60

The Family of Claude Terrasse (1899)
Oil on canvas
32 1/2 x 27 in. (82.6 x 68.6 cm)

Gift of Harry N. Abrams, 1965
65.250
Dauberville, I, no. 187 as "The Terrasse Family," ca. 1893 [*sic*]

Page 15

After the Morning Bath (1910)
Oil on canvas
48 1/4 x 25 1/2 in. (122.5 x 65 cm)

Jacques and Natasha Gelman Collection, 1998
1999.363.5
Dauberville, II, no. 596 as "Morning in the Bathroom" or "Woman at her Toilette," 1910

Page 76

View of the Old Port, Saint Tropez (1911)
Oil on canvas
33 x 34 in. (83.8 x 86.4 cm)

Bequest of Scofield Thayer, 1982
1984.433.1
Dauberville, II, no. 660 as "View of a Mediterranean Harbor," 1911

Page 78

The Dressing Room 1914
Oil on canvas
28 3/8 x 34 3/4 in. (72.1 x 88.3 cm)

Bequest of Scofield Thayer, 1982
1984.433.3
Dauberville, II, no. 811 as "The Dressing Table," 1914

Page 79

Morning in the Garden at Vernonnet (1917)
Oil on canvas
33 3/4 x 44 3/4 in. (85.7 x 113.7 cm)

Bequest of Scofield Thayer, 1982
1984.433.4
Dauberville, II, no. 908 as "Morning" or "The Garden," 1917

Page 88

The Green Blouse (1919)
Oil on canvas
40 1/8 x 26 7/8 in. (101.9 x 68.3 cm)

The Mr. and Mrs. Henry Ittleson Jr. Purchase Fund, 1963
63.64
Dauberville, II, no. 979 as "The Green Blouse" or "The Cup of Coffee," 1919

Page 40

Woman with Mimosa (1924)
Oil on canvas
19 1/8 x 24 5/8 in. (48.5 x 62.5 cm)

Bequest of Ann Eden Woodward (Mrs. William Woodward Jr.), 1975
1978.264.8
Dauberville, III, no. 1256 as "Woman with Mimosa," 1924

Page 44

The Terrace at Vernonnet (1939)
Oil on canvas
58 1/4 x 76 3/4 in. (148 x 194.9 cm)

Gift of Mrs. Frank Jay Gould, 1968
68.1
Dauberville, III, no. 990 as "Vernon Decor," begun in 1920 and finished later by the artist

Pages 52–53

Georges Braque
French, 1882–1963

Candlestick and Playing Cards (Winter 1909–10)
Oil on canvas
Oval: 25 5/8 x 21 3/8 in. (65.1 x 54.3 cm)

The Mr. and Mrs. Klaus G. Perls Collection, 1997
1997.149.12
Worms de Romilly and Laude, 1982, no. 64 as "Still Life," 1909–10
Valsecchi and Carrà, 1971, no. 60 as "Still Life on a Table (The Table)," 1910

Page 68

Still Life with a Pair of Banderillas (1911)
Oil on canvas
25 3/4 x 21 5/8 in. (65.5 x 55 cm)

Jacques and Natasha Gelman Collection, 1998
1999.363.11
Worms de Romilly and Laude, 1982, no. 91 as "Still Life with Banderillas," 1911
Not in Valsecchi and Carrà

Page 70

Guitar and Still Life on a Mantelpiece (1921)
Oil with sand on canvas
51 3/8 x 29 3/8 in. (130.5 x 74.6 cm)

Bequest of Florene M. Schoenborn, 1995
1996.403.11
Valsecchi and Carrà, 1971, no. 263 as "Guitar, Bottle and Fruit Dish (The Mantelpiece)," 1925
Maeght, 1973, p. 89 as "The Mantelpiece (Duo)," 1921

Page 94

Braque (*continued*)

Guitar and Still Life on a Guéridon (1922)
Oil with sand on canvas
75 x 27 3/4 in. (190.5 x 70.5 cm)

Gift of Louise Reinhardt Smith, in honor of
William S. Lieberman, 1979
1979.481
Valsecchi and Carrà, 1971, no. 189 as "Still Life
on a Table," 1921
Maeght, 1973, p. 97 as "The Gueridon," 1922

Page 95

Woman Seated at an Easel (1936)
Oil with sand on canvas
51 1/2 x 63 7/8 in. (130.8 x 162.2 cm)

Bequest of Florene M. Schoenborn, 1995
1996.403.12
Maeght, 1961, p. 1 as "Woman at an Easel (The
Yellow Screen)," 1936

Page 106

The Studio (1949)
Oil on canvas
51 1/2 x 29 1/8 in. (130.8 x 74 cm)

Bequest of Florene M. Schoenborn, 1995
1996.403.13
Maeght, 1959, p. 11 as "Atelier V," 1949

Page 117

Marc Chagall
French, born Russia, 1887–1985

Joseph and Potiphar's Wife (1911)
Watercolor and gouache on paper
12 1/4 x 9 1/2 in. (31.1 x 24.1 cm)

Bequest of Scofield Thayer, 1982
1984.433.60
Meyer, 1963, no. 84 as "Naked Woman Before
Bed," (not dated)

Page 80

Susanna and the Elders 1912
Gouache, metallic paints, pen and ink on paper
6 7/8 x 6 3/4 in. (17.5 x 17.1 cm)

Bequest of Scofield Thayer, 1982
1984.433.57
Not in Meyer

Page 80

The Marketplace, Vitebsk (1917)
Oil on canvas
26 1/8 x 38 1/4 in. (66.4 x 97.2 cm)

Bequest of Scofield Thayer, 1982
1984.433.6
Meyer, 1963, no. 272 as "The Market Place," 1917

Page 81

Giorgio de Chirico
Italian, 1888–1978

Self-Portrait 1911
Oil on canvas
34 3/8 x 27 1/2 in. (87.3 x 69.9 cm)

Gift in memory of Carl Van Vechten and Fania
Marinoff, 1970
1970.166
Fagiolo dell'Arco, 1984, no. 39 as "Self-Portrait,"
1911 and 1913

Page 29

Ariadne 1913
Oil and graphite on canvas
53 3/8 x 71 in. (135.6 x 180 cm)

Bequest of Florene M. Schoenborn, 1995
1996.403.10
Fagiolo dell'Arco, 1984, no. 26 as "Square with
Ariadne," 1913

Page 82

The Jewish Angel 1916
Oil on canvas
26 5/8 x 17 1/4 in. (67.5 x 44 cm)

Jacques and Natasha Gelman Collection, 1998
1999.363.15
Fagiolo dell'Arco, 1984, no. 106 as "Jewish
Angel," 1916

Page 83

Maurice Denis
French, 1870–1943

Springtime (ca. 1897)
Oil on canvas
31 3/4 x 38 1/2 in. (80.6 x 97.8 cm)

Gift of David Allen Devrishian, 1999
1999.180.2a

Page 58

André Derain
French, 1880–1954

Fishing Boats, Collioure (1905)
Oil on canvas
31 7/8 x 39 1/2 in. (81 x 100.3 cm)

Gift of Raymonde Paul, in memory of her
brother, C. Michael Paul, and Purchase, Lila
Acheson Wallace Gift, 1982
1982.179.29
Kellermann, I, no. 59 as "Sailors in Collioure,"
1905

Page 62

The Houses of Parliament Seen at Night (1906)
Oil on canvas
40 1/2 x 47 3/4 in. (102.9 x 121.3 cm)

Robert Lehman Collection, 1975
1975.1.168
Kellermann, I, no. 83 as "London: Westminster
Palace," 1905–06

Page 19

Lucien Gilbert (1906)
Oil on canvas
32 x 23 3/4 in. (81.3 x 60.3 cm)

Gift of Joyce Blaffer von Bothmer, in memory of
Mr. and Mrs. Robert Lee Blaffer, 1975
1975.169
Not in Kellermann

Page 12

The Table (1911)
Oil on canvas
38 x 51 5/8 in. (96.5 x 131.1 cm)

Catharine Lorillard Wolfe Collection, Wolfe
Fund, 1954
54.79
Kellermann, I, no. 284 as "The Table," 1911

Page 32

Jean Dubuffet
French, 1901–1985

Woman Grinding Coffee Christmas 1945
Plaster, oil, and tar with sand on canvas
45 3/4 x 35 in. (116.2 x 88.9 cm)

In honor of Ralph F. Colin, Gift of his wife
Georgia Talmey Colin, 1995
1995.142
Loreau, II, no. 93 as "Coffee-Pot (Woman Coffee
Grinder)," December 1945

Page 118

Apartment Houses, Paris (1946)
Oil with sand and charcoal on canvas
44 7/8 x 57 3/8 in. (114 x 145.7 cm)

Bequest of Florene M. Schoenborn, 1995
1996.403.15
Loreau, II, no. 154 as "Buildings' Facades," July
1946

Page 119

Raoul Dufy
French, 1877–1953

Dusk at La Baie des Anges, Nice (1932)
Oil on canvas
14 7/8 x 18 in. (37.8 x 45.7 cm)

Bequest of Miss Adelaide Milton de Groot
(1876–1967), 1967
67.187.67
Laffaille, II, no. 426 as "Nice, the Promenade des
Anglais with two Palm Trees," 1932

Page 50

Max Ernst
French, born Germany, 1891–1976

Gala Eluard (1924)
Oil on canvas
31 7/8 x 25 5/8 in. (81 x 65.1 cm)

Promised Gift of Muriel Kallis Newman, The
MURIEL KALLIS STEINBERG NEWMAN
Collection
Spies and Metken, II, no. 788 as "Portrait of
Gala," 1924

Page 98

Natalia Gontcharova
French, born Russia, 1881–1962

Decor for the Ballet "Liturgie" (1915)
Watercolor, pencil, cut and pasted paper, silver,
gold, and colored foil on cardboard
21 3/4 x 29 3/8 in. (55.2 x 74.6 cm)

Gift of the Humanities Fund Inc., 1972
1972.146.10

Page 35

Juan Gris
Spanish, 1887–1927

Violin and Playing Cards (1913)
Oil on canvas
39 3/8 x 25 3/4 in. (100 x 65.4 cm)

Bequest of Florene M. Schoenborn, 1995
1996.403.14
Cooper and Potter, I, no. 58 as "Violin and
Playing Cards," 1913

Page 74

Jean Hélion
French, 1904–1987

Newspaper Readers 1948
Oil on canvas
58 x 45 in. (147.3 x 114.3 cm)

Gift of The Joseph Cantor Foundation, 1982
1982.148.2

Page 115

František Kupka
Czech, 1871–1957

Vertical and Diagonal Planes (ca. 1913–14)
Oil on canvas
24 1/8 x 19 3/4 in. (61.3 x 50.2 cm)

Gift of Joseph H. Hazen Foundation Inc., 1971
1971.111

Page 34

Roger de La Fresnaye
French, 1885–1925

Georges de Miré (1910)
Oil on canvas
50 3/4 x 38 1/2 in. (128.9 x 97.8 cm)

Gift of Mr. and Mrs. Nathan Cummings, 1962
62.261
Seligman, 1969, no. 76 as "Portrait: Georges de
Miré," 1910

Page 28

Artillery (1911)
Oil on canvas
51 1/4 x 62 3/4 in. (130.2 x 159.4 cm)

Gift of Florene M. Schoenborn, 1991
1991.397
Seligman, 1969, no. 111 as "Artillery, with a Flag,"
1911

Page 72

Fernand Léger
French, 1881–1955

Woman with a Cat 1921
Oil on canvas
51 3/8 x 35 1/4 in. (130.5 x 89.5 cm)

Gift of Florene M. Schoenborn, 1994
1994.486
Bauquier, 1993, no. 306 as "Woman with Cat,"
1921

Page 90

Three Women by a Garden 1922
Oil on canvas
25 1/2 x 36 in. (64.8 x 91.4 cm)

Bequest of Mr. and Mrs. Allan D. Emil, in honor
of William S. Lieberman, 1987
1987.125.1
Bauquier, 1993, no. 332 as "Figures in a Garden,"
1922

Page 91

Divers (Blue and Black) 1942–43
Oil on canvas
66 1/4 x 50 1/4 in. (168.2 x 127.5 cm)

Jacques and Natasha Gelman Collection, 1998
1999.363.37

Page 114

Albert Marquet
French, 1875–1947

The Pont Neuf, Paris (1935)
Oil on canvas
35 x 45 3/4 in. (88.9 x 116.2 cm)

Gift of Mrs. Charles S. Payson, 1966
66.5

Page 51

View from a Balcony 1945
Oil on canvas
25 5/8 x 19 3/4 in. (65.1 x 50.2 cm)

Partial and Promised Gift of Mr. and Mrs.
Douglas Dillon, 1998
1998.412.2

Page 116

Henri Matisse
French, 1869–1954

The Young Sailor II 1906
Oil on canvas
40 x 32 3/4 in. (101.5 x 83 cm)

Jacques and Natasha Gelman Collection, 1998
1999.363.41

Page 64

Nasturtiums with the Painting "Dance II" (1912)
Oil on canvas
75 1/2 x 45 3/8 in. (191.8 x 115.3 cm)

Bequest of Scofield Thayer, 1982
1984.433.16

Page 77

Girl by a Window (1921)
Oil on canvas
18 3/8 x 21 7/8 in. (46.7 x 55.6 cm)

Gift of Alice Albright Arlen, in honor of her
mother, Josephine Patterson Albright, 1994
1994.545

Page 92

The Goldfish Bowl (Winter 1921–22)
Oil on canvas
21 3/8 x 25 3/4 in. (54.3 x 65.4 cm)

Bequest of Scofield Thayer, 1982
1984.433.19

Page 93

Reclining Odalisque (1926)
Oil on canvas
15 1/8 x 21 5/8 in. (38.4 x 54.9 cm)

Bequest of Miss Adelaide Milton de Groot
(1876–1967), 1967
67.187.82

Page 47

Jean Metzinger
French, 1883–1956

Table by a Window November 1917
Oil on canvas
32 x 25 5/8 in. (81.5 x 65.1 cm)

Purchase, The M. L. Annenberg Foundation,
Joseph H. Hazen Foundation Inc., and Joseph H.
Hazen Gifts, 1959
59.86

Page 39

Joan Miró
Spanish, 1893–1983

Dutch Interior (1928)
Oil on canvas
51 1/8 x 38 1/8 in. (129.9 x 96.8 cm)

Bequest of Florene M. Schoenborn, 1995
1996.403.8
Dupin and Lelong-Mainaud, I, no. 306 as
"Dutch Interior (III)"

Page 101

Amedeo Modigliani
Italian, 1884–1920

Juan Gris (1915)
Oil on canvas
21 5/8 x 15 in. (54.9 x 38.1 cm)

Bequest of Miss Adelaide Milton de Groot
(1876–1967), 1967
67.187.85
Cachin and Ceroni, 1972, no. 99 as "Portrait of
Juan Gris," 1915
Parisot, 1991, no. 37/1915 as "Portrait of Juan
Gris," 1915
Patani, 1991, no. 104 as "Juan Gris," 1915

Page 33

Reclining Nude (1917)
Oil on canvas
23 7/8 x 36 1/2 in. (60.6 x 92.7 cm)

The Mr. and Mrs. Klaus G. Perls Collection, 1997
1997.149.9
Cachin and Ceroni, 1972, no. 199 as "Reclining
Nude with Hands Behind her Head," 1917
Parisot, 1991, no. 40/1917 as "Reclining Nude
with Hands Behind her Head," 1917
Patani, 1991, no. 208 as "Reclining Nude with
Hands Behind her Head," 1917

Page 86

Flower Vendor (1919)
Oil on canvas
45 7/8 x 28 7/8 in. (116.5 x 73.3 cm)

Bequest of Florene M. Schoenborn, 1995
1996.403.9
Cachin and Ceroni, 1972, no. 331 as "Seated
Young Woman (The Flower Vendor)," 1919
Parisot, 1991, no. 12/1919 as "The Flower
Vendor," 1919
Patani, 1991, no. 343 as "Seated Woman
(The Flower Vendor)," 1919

Page 87

Jeanne Hébuterne (1919)
Oil on canvas
36 x 28 3/4 in. (91.4 x 73 cm)

Gift of Mr. and Mrs. Nate B. Spingold, 1956
56.184.2
Cachin and Ceroni, 1972, no. 326 as "Portrait of
Jeanne Hébuterne," 1919
Parisot, 1991, no. 11/1919 as "Jeanne Hébuterne,"
1919
Patani, 1991, no. 338 as "Jeanne Hébuterne," 1919

Page 41

Claude Monet
French, 1840–1926

The Houses of Parliament Seen in Fog 1903
Oil on canvas
32 x 36 3/8 in. (81.3 x 92.4 cm)

Bequest of Julia W. Emmons, 1956
56.135.6
Wildenstein, IV, no. 1609 as "Houses of
Parliament, Fog Effect," 1903

Page 18

Reflections, the Water Lily Pond at Giverny
(ca. 1920)
Oil on canvas
51 1/4 x 79 in. (130.2 x 200.7 cm)

Gift of Louise Reinhardt Smith, 1983
1983.532
Wildenstein, IV, no. 1858 as "Water-Lilies,
Reflections of Weeping Willows," 1916–19

Page 89

Jules Pascin
American, born Bulgaria, 1885–1930

Pierre Mac Orlan (1924)
Oil on canvas
36 1/4 x 28 3/4 in. (92.1 x 73 cm)

The Mr. and Mrs. Klaus G. Perls Collection, 1997
1997.149.8
Hemin et al., I, pl. XIX as "Portrait of Pierre
Mac Orlan," Paris, 1924

Page 99

Seated Model (1925)
Oil on canvas
39 1/2 x 32 in. (100.3 x 81.3 cm)

Bequest of Miss Adelaide Milton de Groot
(1876–1967), 1967
67.187.168
Hemin et al., I, no. 521 as "Woman Half-
Dressed," Paris, Bd de Clichy, 1925

Page 46

Girl with a Kitten (ca. 1926)
Oil and charcoal on canvas
31 5/8 x 25 1/4 in. (80.3 x 64.1 cm)

Gift of Leonore S. Gershwin 1987 Trust, 1993
1993.89.2
Hemin et al., I, no. 508 as "Portrait of a Little
Girl," 1925–27

Page 99

Francis Picabia
French, 1879–1953

Star Dancer with Her Dance School 1913
Watercolor on paper
22 x 30 in. (55.6 x 76.2 cm)

Alfred Stieglitz Collection, 1949
49.70.12

Page 36

Pablo Picasso
Spanish, 1881–1973

Harlequin 1901
Oil on canvas
32 5/8 x 24 1/8 in. (82.7 x 61.2 cm)

Gift of Mr. and Mrs. John L. Loeb, 1960
60.87
Z, I, no. 79 as "Harlequin Propped on Elbows,"
Paris, 1901
D/B, 1966, no. VI.22; as "Harlequin," Paris, 1901
Palau i Fabre, 1981, no. 670 as "Harlequin
Leaning on a Table," Paris, 1901

Page 16

The Blind Man's Meal (1903)
Oil on canvas
37 1/2 x 37 1/4 in. (95.3 x 94.6 cm)

Purchase, Mr. and Mrs. Ira Haupt Gift, 1950
50.188
Z, I, no. 168 as "The Blindman's Meal,"
Barcelona, 1903
D/B, 1966, no. IX.32 as "The Blind Man's
Meal," Barcelona, 1903
Palau i Fabre, 1981, no. 920 as "The Blind Man's
Meal," Barcelona, 1903

Page 17

The Actor (Winter 1904–05)
Oil on canvas
76 3/8 x 44 1/8 in. (194 x 112.1 cm)

Gift of Thelma Chrysler Foy, 1952
52.175
Z, I, 291 as "The Actor," Paris, 1905
D/B, 1966, no. XII.1 as "The Actor," Paris,
winter, 1904–05
Palau i Fabre, 1981, no. 1017 as "The Actor,"
Paris, end of 1904

Page 20

Picasso (continued)

The Coiffure (1906)
Oil on canvas
68 7/8 x 39 1/4 in. (174.9 x 99.7 cm)

Catharine Lorillard Wolfe Collection, Wolfe
Fund, 1951; acquired from The Museum of
Modern Art, Anonymous Gift
53.140.3
Z, I, no. 313 as "The Hairdresser," Paris, 1905
D/B, 1966, no. XIV.20 as "The Coiffure," Paris
or Gosol, spring 1906
Palau i Fabre, 1981, no. 1213 as "The Coiffure,"
Paris or Gosol, spring 1906

Page 21

Self-Portrait 1906
Oil on canvas mounted on wood
10 1/2 x 7 3/4 in. (26.7 x 19.7 cm)

Jacques and Natasha Gelman Collection, 1998
1999.363.59
Z, I, no. 371, as "Head of a Young Man," Paris,
1906
D/B, 1966, no. XVI.27 as "Head of a Young
Man," Paris, autumn 1906

Page 65

Gertrude Stein (1906)
Oil on canvas
39 3/8 x 32 in. (100 x 81.3 cm)

Bequest of Gertrude Stein, 1946
47.106
Z, I, no. 352 as "Portrait of Miss Gertrude Stein,"
Paris, 1906
D/B, 1966, no. XVI.10 as "Portrait of Gertrude
Stein," Paris, autumn 1906
Palau i Fabre, 1981, no. 1339 as "Portrait of
Gertrude Stein," Paris, spring–summer 1906

Page 22

Seated Nude (1908)
Charcoal and graphite on paper
24 7/8 x 18 7/8 in. (63.2 x 47.9 cm)

Bequest of Scofield Thayer, 1982
1984.433.278
Z, II², no. 706
Not in D/R
Not in Palau i Fabre

Page 66

Bust of a Man (1908)
Oil on canvas
24 1/2 x 17 1/8 in. (62.2 x 43.5 cm)

Bequest of Florene M. Schoenborn, 1995
1996.403.5
Z, II¹, no. 76 as "Bust of a Man," Paris, autumn
1908
D/R, 1979, no. 143 as "Head and Shoulders of a
Man," Paris, spring 1908

Palau i Fabre, 1990, no. 276 as "Negroid Bust,"
Paris, autumn 1908

Page 66

Nude in an Armchair (Winter 1909–10)
Oil on canvas
32 x 25 3/4 in. (81.3 x 65.4 cm)

The Mr. and Mrs. Klaus G. Perls Collection, 1997
1997.149.7
Z, II² no. 198 as "Woman Seated in an
Armchair," Paris, winter 1909
D/R, 1979, no. 333 as "Woman Seated in an
Armchair," Paris, winter 1909–10
Palau i Fabre, 1990, no. 470 as "Woman Sitting
Beside a Window," Paris, winter 1909–10

Page 67

Still Life with a Pipe Rack (1911)
Oil on canvas
20 x 50 3/8 in. (50.8 x 128 cm)

The Mr. and Mrs. Klaus G. Perls Collection, 1997
1997.149.6
Z, II² no. 726 as "Pipes, Cup, Coffee-Pot and
Small Carafe," Paris, winter 1910–11
D/R, 1979, no. 417 as "Pipes, Cup, Coffee-Pot
and Carafe," Céret, summer 1911(?)
Palau i Fabre, 1990, no. 629 as "Ocean," Paris,
winter 1911–12

Pages 68–69

Still Life with a Bottle of Rum (1911)
Oil on canvas
24 1/8 x 19 7/8 in. (61.3 x 50.5 cm)

Jacques and Natasha Gelman Collection, 1998
1999.363.63
Z, II¹, no. 267 as "The Bottle of Rum," Céret,
summer 1911
D/R, 1979, no. 414 as "The Bottle of Rum,"
Céret, summer 1911
Palau i Fabre, 1990, no. 603 as "The Bottle of
Rum," Céret, summer 1911

Page 71

Guitar and Clarinet on a Mantelpiece 1915
Oil on canvas
51 1/4 x 38 1/4 in. (130.2 x 97.2 cm)

Bequest of Florene M. Schoenborn, 1995
1996.403.3
Z, II², no. 540 as "Guitar on a Mantelpiece,"
Paris, 1915
D/R, 1979, no. 812 as "Guitar and Clarinet on a
Mantelpiece," Paris 1915
Palau i Fabre, 1990, no. 1361 as "Guitar and
Clarinet on a Mantelpiece," Paris, autumn–
winter 1915

Page 75

Woman in White (1923)
Oil on canvas
39 x 31 1/2 in. (99.1 x 80 cm)

Rogers Fund, 1951; acquired from The Museum
of Modern Art, Lillie P. Bliss Collection
53.140.4
Z, V, no. 1 as "Seated Woman with Arms
Crossed," 1923

Page 45

Mandolin, Fruit Bowl, and Plaster Arm 1925
Oil on canvas
38 1/2 x 51 1/4 in. (97.8 x 130.2 cm)

Bequest of Florene M. Schoenborn, 1995
1996.403.2
Z, V, no. 444 as "Mandolin, Fruit Bowl and
Plaster Arm," 1925

Page 100

Harlequin 1927
Oil on canvas
32 x 25 5/8 in. (81.3 x 65.1 cm)

The Mr. and Mrs. Klaus G. Perls Collection, 1997
1997.149.5
Z, VII, no. 80 as "Harlequin," 1927

Page 102

Nude Standing by the Sea 1929
Oil on canvas
51 1/8 x 38 1/8 in. (129.9 x 96.8 cm)

Bequest of Florene M. Schoenborn, 1995
1996.403.4
Z, VII, no. 252 as "Woman," April 7, 1929

Page 103

The Dreamer July 1932
Oil on canvas
39 7/8 x 36 3/4 in. (101.3 x 93.3 cm)

The Mr. and Mrs. Klaus G. Perls Collection, 1997
1997.149.4
Z, VII, no. 407 as "Sleeping Nude with Flowers,"
July 1932

Page 104

Girl Reading at a Table 1934
Oil and enamel on canvas
63 7/8 x 51 3/8 in. (162.2 x 130.5 cm)

Bequest of Florene M. Schoenborn, in honor of
William S. Lieberman, 1995
1996.403.1
Z, VIII, no. 246 as "Woman Writing," [sic], 1934

Page 105

Picasso (*continued*)

Girl Sleeping at a Table December 18, 1936
Oil on canvas
38 1/4 x 51 1/4 in. (97.2 x 130.2 cm)

The Mr. and Mrs. Klaus G. Perls Collection, 1997
1997.149.3
Z, VIII, no. 309 as "The Poet," December 18, 1936

Page 107

Dora Maar in an Armchair October 26, 1939
Oil on canvas
28 7/8 x 23 3/4 in. (73.3 x 60.3 cm)

The Mr. and Mrs. Klaus G. Perls Collection, 1998
1998.23
Not in Zervos

Page 113

Diego Rivera
Mexican, 1886–1957

Table on a Café Terrace (1915)
Oil on canvas
23 7/8 x 19 1/2 in. (60.6 x 49.5 cm)

Alfred Stieglitz Collection, 1949
49.70.51

Page 38

Georges Rouault
French, 1871–1958

Three Judges (ca. 1938)
Oil on canvas
27 1/4 x 21 1/2 in. (69.2 x 54.6 cm)

The Frederick and Helen Serger Collection, Bequest of Helen Serger, in honor of William S. Lieberman, 1989
1990.274.3

Page 112

Henri Rousseau
French, 1844–1910

The Repast of a Lion (ca. 1907)
Oil on canvas
44 3/4 x 63 in. (113.7 x 160 cm)

Bequest of Sam A. Lewisohn, 1951
51.112.5

Pages 26–27

André Dunoyer de Segonzac
French, 1884–1974

Model Dressing (1912)
Oil on canvas
39 3/8 x 25 5/8 in. (100 x 65.1 cm)

Bequest of Miss Adelaide Milton de Groot (1876–1967), 1967
67.187.100

Page 31

Gino Severini
Italian, 1883–1966

Dancer-Airplane Propeller-Sea 1915
Oil on canvas
29 5/8 x 30 3/4 in. (75.2 x 78.1 cm)

Alfred Stieglitz Collection, 1949
49.70.3
Fonti, 1988, no. 239 as "Dancer=Propeller=Sea," 1915

Page 37

Chaim Soutine
French, born Lithuania, 1893–1943

The Terrace at Vence (ca. 1922)
Oil on canvas
24 1/2 x 19 3/4 in. (60.2 x 50.2 cm)

Gift of Hon. and Mrs. Peter I. B. Lavan, 1964
64.147
Tuchman et al., I, no. 102 as "Landscape with Figures," ca. 1922

Page 48

The Ray (ca. 1924)
Oil on canvas
32 x 39 3/8 in. (81.3 x 100 cm)

The Mr. and Mrs. Klaus G. Perls Collection, 1997
1997.149.1
Tuchman et al., I no. 61 as "Still Life with Rayfish," ca. 1924

Page 96

View of Cagnes (ca. 1924–25)
Oil on canvas
23 3/4 x 28 3/4 in. (60.3 x 73 cm)

The Mr. and Mrs. Klaus G. Perls Collection, 1997
1997.149.2
Tuchman et al., I, no. 135 as "Houses of Cagnes," ca. 1924–25

Page 97

Madeleine Castaing (ca. 1929)
Oil on canvas
39 3/8 x 28 7/8 in. (100 x 73.3 cm)

Bequest of Miss Adelaide Milton de Groot (1876–1967), 1967
67.187.107
Tuchman et al., II, no. 138 as "Portrait of Madeleine Castaing," ca. 1929

Page 49

Yves Tanguy
American, born France, 1900–1955

The Hostages 1934
Oil on canvas
25 1/2 x 19 3/4 in. (64.8 x 50.2 cm)

Bequest of Kay Sage Tanguy, 1963
66.8.1

Page 54

The Mirage of Time 1954
Oil on canvas
39 x 32 in. (99.1 x 81.3 cm)

George A. Hearn Fund, 1955
55.95

Page 55

Pavel Tchelitchew
American, born Russia, 1898–1957

The Whirlwind 1939
Oil on canvas
28 1/2 x 23 3/4 in. (72.4 x 60.3 cm)

Arthur Hoppock Hearn Fund, 1950
50.38

Page 54

Maurice Utrillo
French, 1883–1955

The Old Windmill at Sannois (1911)
Oil on cardboard
21 1/8 x 25 5/8 in. (53.7 x 65.1 cm)

Bequest of Miss Adelaide Milton de Groot (1876–1967), 1967
67.187.110
Pétridès, I, no. 264 as "Old Windmill at Sannois," ca. 1911

Page 30

Félix Vallotton
Swiss, 1865–1925

Flowering Peach Trees, Provence 1922
Oil on canvas
28 3/4 x 23 3/4 in. (73 x 60.3 cm)

Bequest of Miss Adelaide Milton de Groot (1876–1967), 1967
67.187.114

Page 42

Landscape at Saint Jeannet, Provence 1922
Oil on canvas
31 3/4 x 25 1/2 in. (80.6 x 64.8 cm)

Bequest of Miss Adelaide Milton de Groot (1876–1967), 1967
67.187.115

Page 42

Jacques Villon
French, 1875–1963

The Dining Table 1912
Oil on canvas
25 3/4 x 32 in. (65.4 x 81.3 cm)

Purchase, Gift of Mr. and Mrs. Justin K. Thannhauser, by exchange, 1983
1983.169.1

Page 73

Maurice de Vlaminck
French, 1876–1958

André Derain (1906)
Oil on cardboard
10 5/8 x 8 3/4 in. (27 x 22.2 cm)

Jacques and Natasha Gelman Collection, 1998
1999.363.83

Page 63

Edouard Vuillard
French, 1868–1940

Girl at a Piano (ca. 1899)
Oil on cardboard
18 1/2 x 17 1/2 in. (47 x 44.5 cm)

Robert Lehman Collection, 1975
1975.1.224

Page 14

Luncheon (1901)
Oil on cardboard
8 3/4 x 17 in. (22.2 x 43.2 cm)

Bequest of Mary Cushing Fosburgh, 1978
1979.135.28

Page 61

Place Vintimille, Paris (1916)
Distemper on canvas
64 x 90 in. (162.6 x 228.6 cm)

Promised Gift of an Anonymous Donor

Pages 84–85

Morning in the Garden at Vaucresson (1923 and 1937)
Distemper on canvas
59 1/2 x 43 5/8 in. (151.2 x 110.8 cm)

Catharine Lorillard Wolfe Collection, Wolfe Fund, 1952
52.183

Page 43

CATALOGUES RAISONNÉS

Bauquier, Georges. *Fernand Léger: Catalogue raisonné de l'oeuvre peint, 1903–1937.* 6 vols. Paris, 1990–93.

Cachin, Françoise, and Abrogio Ceroni. *Tout l'oeuvre peint de Modigliani.* Translated by Simone Darses. Paris, 1972.

Cooper, Douglas, and Margaret Potter. *Juan Gris: Catalogue raisonné de l'oeuvre peint.* 2 vols. Paris, 1977

Daix, Pierre, and Georges Boudaille. *Picasso: The Blue and Rose Periods. A Catalogue Raisonné, 1900–1906.* Translated by Phoebe Pool. Greenwich, Connecticut, 1966.

Daix, Pierre, and Joan Rosset. *Picasso: The Cubist Years, 1907–1916. A Catalogue Raisonné of the Paintings and Related Works.* Translated by Dorothy S. Blair. Boston, 1979.

Dauberville, Jean, and Henry Dauberville. *Bonnard: Catalogue raisonné de l'oeuvre peint, 1888–1947.* 4 vols. Paris, 1966–74.

Dupin, Jacques, and Ariane Lelong-Mainaud. *Joan Miró: Catalogue raisonné. Paintings Vol. I: 1908–1930.* Translated by Cole Swensen and Unity Woodman. Paris, 1999.

Palau i Fabre, Josep. *Picasso: The Early Years, 1881–1907.* Translated by Kenneth Lyons. New York, 1981.

Palau i Fabre, Josep. *Picasso: Cubism, 1907–1917.* Translated by Susan Branyas, Richard-Lewis Rees, and Patrick Zabalbeascoa, New York, 1990

Fagiolo dell'Arco, Maurizio. *L'opera completa di de Chirico, 1908–1924.* Milan, 1984.

Fonti, Daniela. *Gino Severini: Catalogo ragionato.* Milan, 1988.

Hemin, Yves, with Guy Krogh, Klaus Perls, and Abel Rambert. *Pascin: Catalogue raisonné: Peintures, aquarelles, pastels, dessins.* 2 vols. Paris, 1984–87.

Kellermann, Michel. *André Derain. Catalogue raisonné de l'oeuvre peint (1895–1918).* 2 vols. Paris, 1992–96.

Laffaille, Maurice. *Raoul Dufy: Catalogue raisonné de l'oeuvre peint.* 4 vols. Geneva, 1972–77.

Loreau, Max., ed. *Catalogue des travaux de Jean Dubuffet.* 36 vols. Lausanne, 1966–88.

Maeght, ed. *Catalogue de l'oeuvre de Georges Braque: Peintures 1916–1947.* 5 vols. Paris, 1959–73.

Meyer, Franz. *Marc Chagall: Life and Work.* Translated by Robert Allen. New York, 1963.

Parisot, Christian. *Modigliani: Catalogue raisonné: Peintures, dessins, aquarelles.* Rome, 1991.

Patani, Osvaldo. *Amedeo Modigliani. Catalogo Generale Dipenti.* Milan, 1991.

Pétridès, Paul. *L'Oeuvre complet de Maurice Utrillo.* 5 vols. Paris, 1959–74.

Seligman, Germain. *Roger de La Fresnaye: With a Catalogue Raisonné.* New York, 1969.

Spies, Werner, with Sigrid Metken and Günther Metken. *Max Ernst: Oeuvre-Katalog.* 5 vols. English translation by Valérie Brière. Houston, Texas, and Cologne, Germany: De Menil Foundation, 1975–87.

Tuchman, Maurice with Esi Dunow, and Klaus Perls. *Chaim Soutine (1893–1943): Catalogue raisonné—Werkverzeichnis.* 2 vols. Cologne, 1993.

Valsecchi, Marco, and Massimo Carrà. *L'opera completa di Braque dalla scompozione cubista al recupero dell'oggetto: 1908–1929.* Milan, 1971.

Wildenstein, Daniel. *Monet: Catalogue raisonné. Werkverzeichnis.* 4 vols. Cologne, 1996.

Worms de Romilly, Nicole, and Jean Laude. *Braque: Le cubisme fin 1907–1914.* Paris, 1982.

Zervos, Christian. *Pablo Picasso: Oeuvres.* 33 vols. Paris, 1932–78.

NOTE: The Alice B. Toklas letters on pages 23–25 are in The Metropolitan Museum of Art Archives.

BACK COVER (reading from upper left): *The Young Sailor II*, by Henri Matisse (see p. 64); *Harlequin*, by Pablo Picasso (see p. 16); *Flower Vendor*, by Amedeo Modigliani (see p. 87); *Woman with a Cat*, by Fernand Léger (see p. 90)